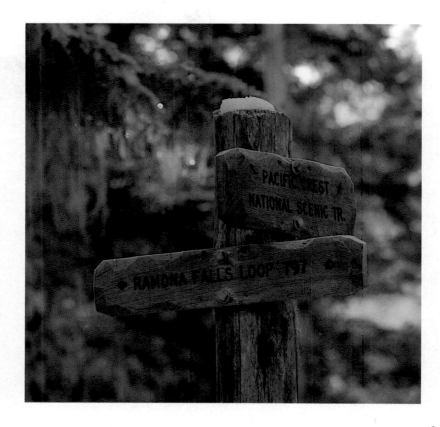

OREGON'S NATIONAL FORESTS

PHOTOGRAPHY BY ROBERT M. REYNOLDS
TEXT BY JOAN CAMPF

GRAPHIC ARTS CENTER PUBLISHING COMPANY
PORTLAND, OREGON

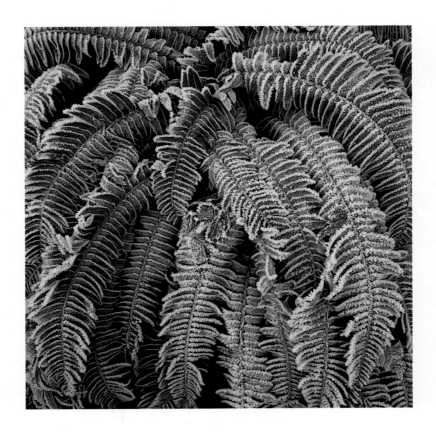

International Standard Book Number 1-55868-016-0
Library of Congress Catalog Number 89-81617
© MCMXC by Graphic Arts Center Publishing Company
P.O. Box 10306 • Portland, Oregon 97210 • 503/226-2402
Editor-in-Chief • Douglas A. Pfeiffer
Associate Editor • Jean Andrews
Designers • Robert M. Reynolds and Letha Gibbs Wulf
Typographer • Harrison Typesetting, Inc.
Printer • Dynagraphics, Inc.
Bindery • Lincoln & Allen
Printed in the United States of America

■ *Title Page:* Mount Hood NF. Trails intersect on the east face of Mount Hood. ■ *Above:* Willamette NF. Sword fern is a common sight in the Willamette. ■ *Right:* Wallowa-Whitman NF. Eagle Cap Wilderness protects thirty-two peaks over eight thousand feet high. The waters of Blue Lake, in Eagle Cap Wilderness, lie placid on this autumn morning.

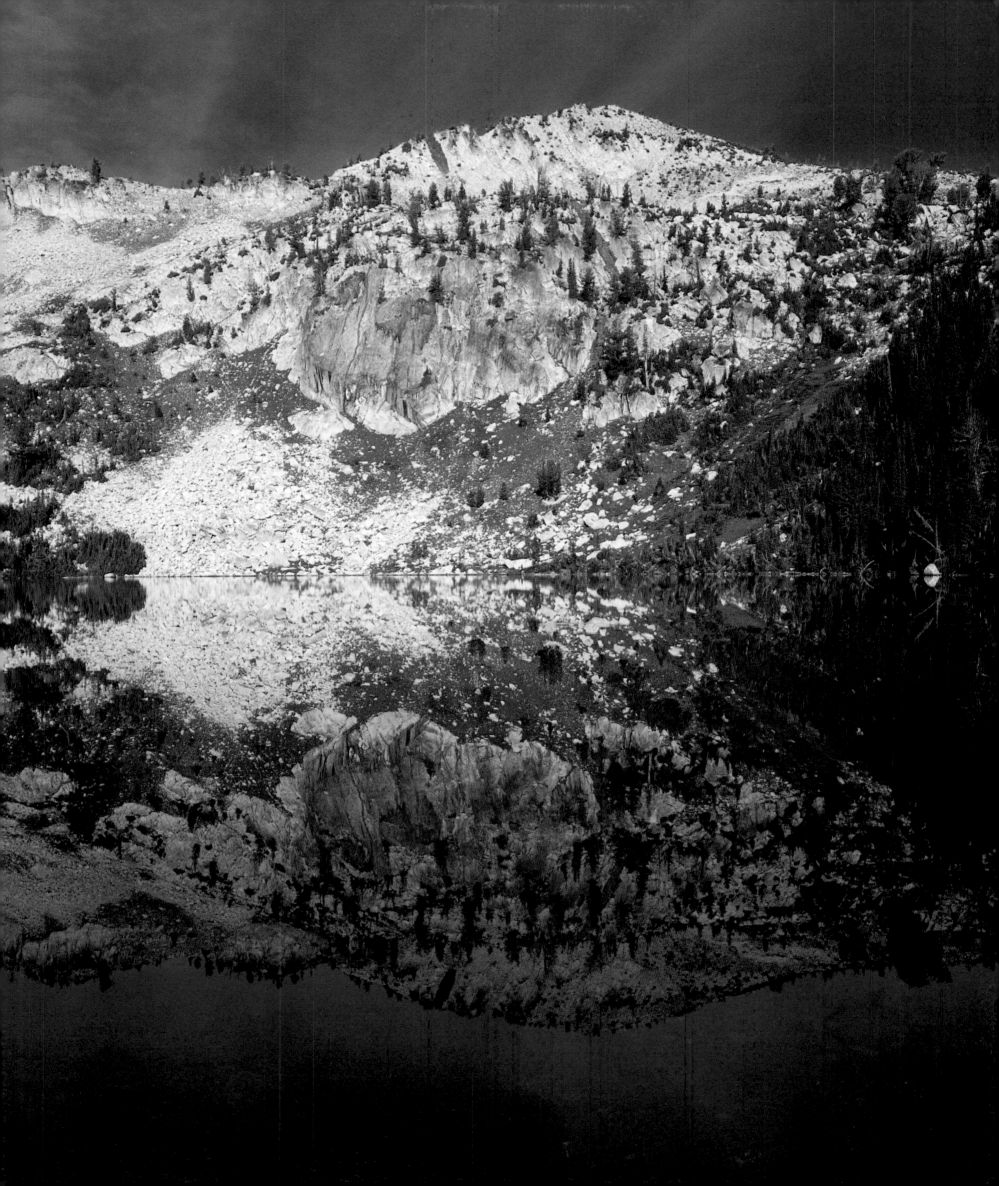

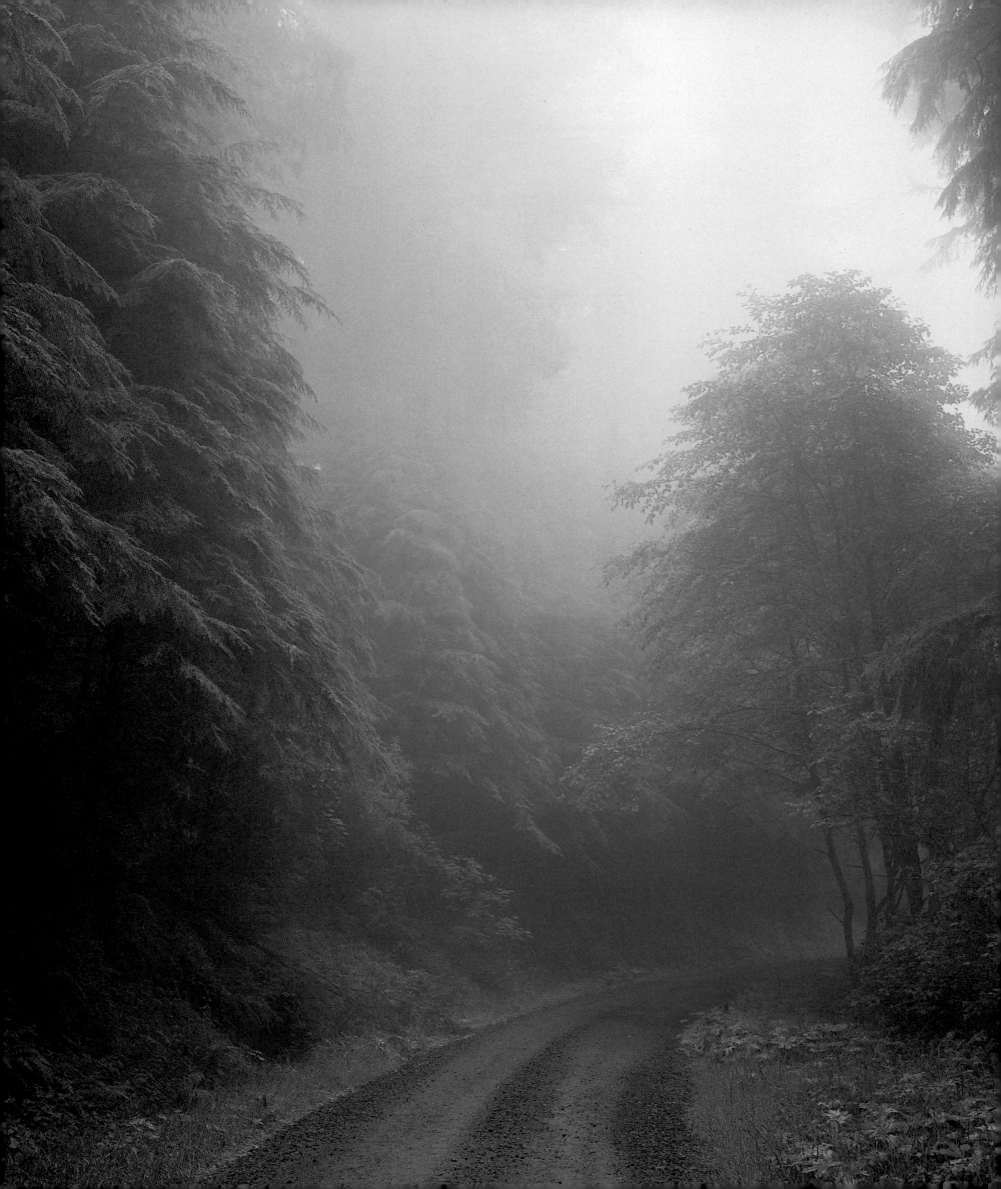

OREGON'S

What do you need to know to love a national forest? Do you need to know that in Oregon it plunges into the sea, climbs mountains, crosses deserts, cuts through canyons? Do you need to fish its waters, hunt its hills, raft its rivers before you can say this is mine?

Do you really need to know a mallard from a teal to sense something wild and wonderful as ducks scatter to the sky on a soft spring morning? Do you need to know a Douglas-fir from a western hemlock to stand beneath their majesty, let their coolness enter your bones, let their size humble you, let their past teach you? Do you need to know one pair of skis from another, one kind of wildflower from another, to love a mountain or a meadow?

What matters is that you are there, that you see and feel, smell and taste. That you let the saltwater cover

■ Left: *Siuslaw NF. The Siuslaw National Forest controls 630,395 acres and opens to the panorama of the Pacific Ocean.* ■ Overleaf: *Mount Hood NF. While the mighty Columbia River eroded a channel at a rate equal to the uplift of the Cascade Range, other rivers were diverted. Multnomah Falls drops a total of 620 feet in two sections.*

your lips; feel the sand squish between your toes; see the hawk sail away; smell the sunshine on the wind. What matters is that your joy comes tumbling out as you slide on your seat down a glacier, ice ax and laughter in front of you. Or that you wake early to watch a doe and her dappled fawn drink from a spring surrounded by willows and warblers and your eyes. What matters is that you can leave behind the clatter of the city, the clutter of your mind so that you make room for the silences, and the silences make room for the sounds.

How else could you hear an elk in the brush, a woodpecker drumming, a chickadee singing, a pika scolding if you cannot quiet the voices that pound in your brain? How else would you know the sound of water over rocks, of breezes through leaves, of a smile in a heart?

The mind can be a deafening roar. Leave it behind. And you can learn to love a forest.

Watch a beetle cross your boot. No need to shove it aside here. This is his lunch table, not yours. Let the rain fall. Throw your umbrella away. There is a beach that wants you free. Woods that want you unencumbered. A self you can only find if you let it go. Eyes that can only see out if they are not too busy looking in.

The track on your path is a porcupine dragging his whisk broom tail. The head parting the water is a muskrat with a mouth full of grass. The hole in the hill belongs to a mountain beaver. The cup in the rock crevice is home to a cañon wren.

If you look carefully, you will know that a people lived here before you. Medicine trees will be notched, rock cairns will be left. These forests were their food, their clothes. These animals, this moon, this sun were their spirits. Yew wood made their bows, beargrass their baskets; spider webs closed their wounds. If you listen, I swear, the wind will bring their song.

So what are these forests that beckon us? They are trees, some of which are among the largest and oldest forms of life ever created on earth. Ever. They are trees that suck fogs and mists and rains from the sky. They shelter elk and deer, meadow voles and mice. They house the wood duck and the weasel, the owl and the squirrel, our past, our future. What insect would not love a tree? What lichen would not grow there? What black bear not hide inside?

Forests are rivers that burst clean and pure out of the rock-strewn hillsides and the lush green grass. They are milky-emerald torrents that slam through narrow cliff walls and broad blue ribbons that just meander. They are rivers that are still home to wild fish, to great blue herons that ply the shores. They are rocks that beg you to climb them, and rocks that ask you to sit. They are skies that are filled with the haunting sound of geese, and skies that are swept clean at dusk by the nighthawks. They are mountains that poke a hole in the sky, and mountains that plunge to the ground. They are gigantic sand dunes and spectacular waterfalls, hidden alpine lakes and duck-filled marshes. They are places to get lost. And places to get found. There are thirteen national forests in all, in this place called Oregon.

What do you need to know to love a forest? You need to cherish this land and all therein, so you, so we, can come again and again and again.

NATIONAL FORESTS

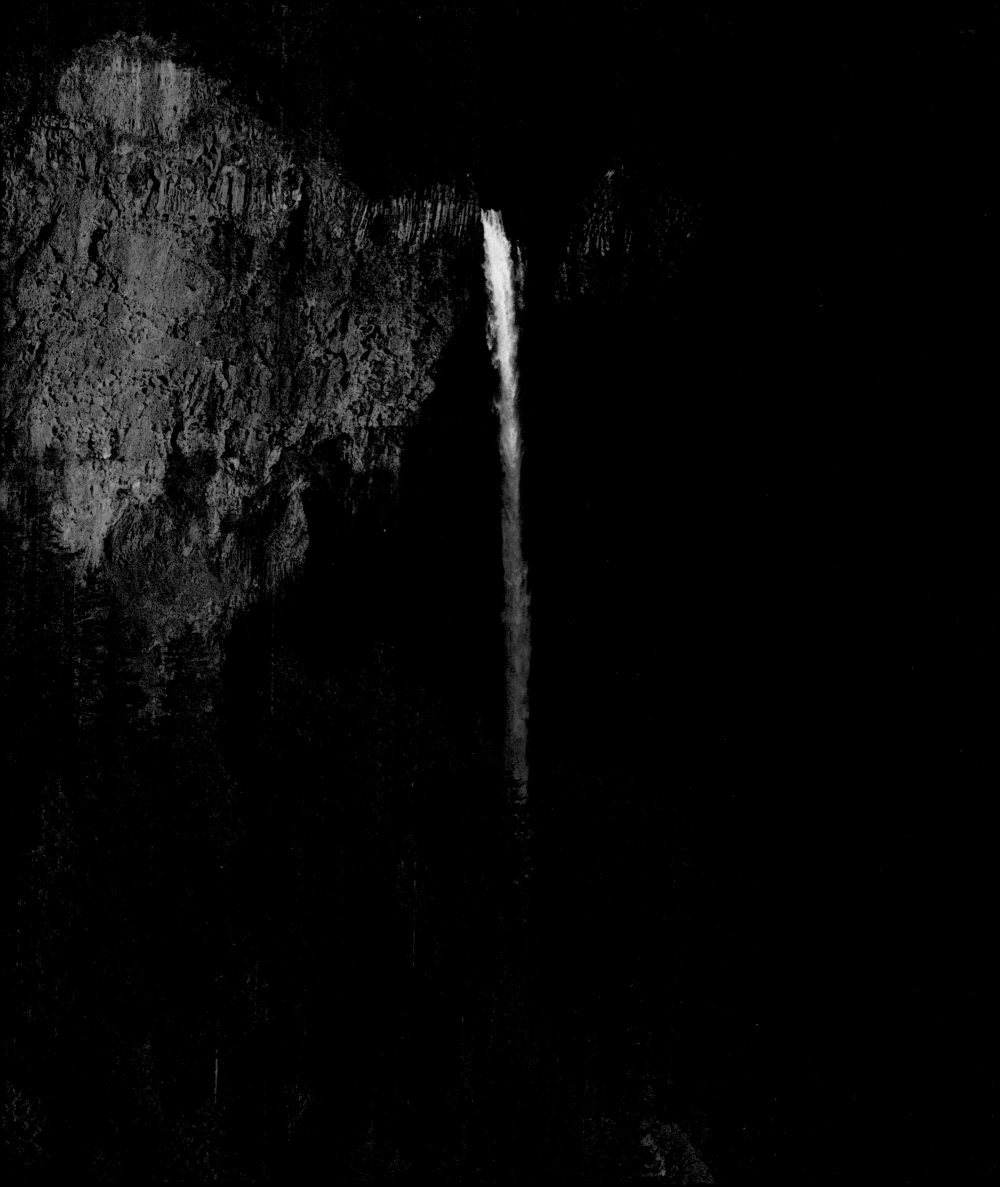

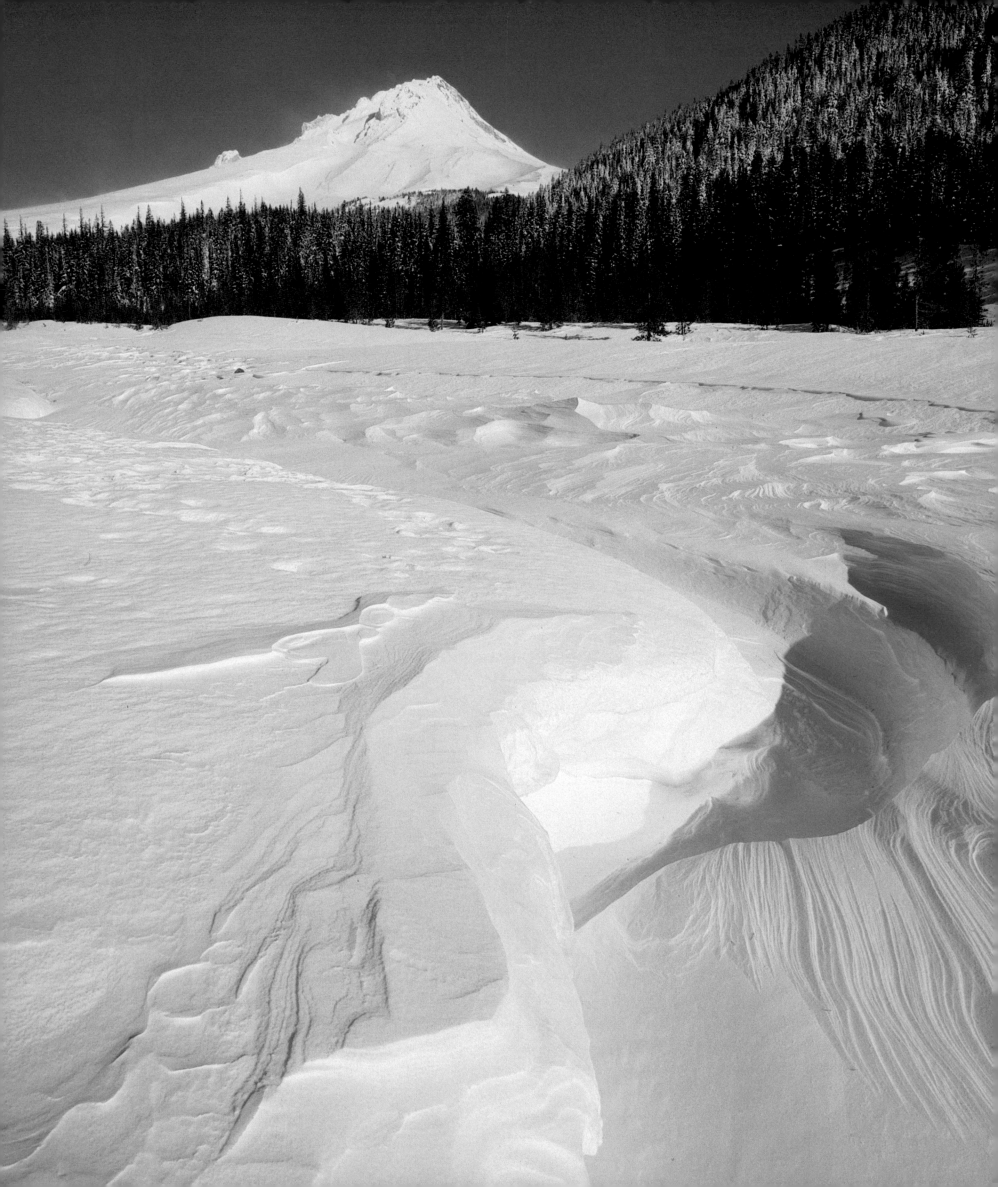

MT HOOD

MOUNT HOOD · This forest is a mountain. And this mountain is a beauty. And at its feet are a people who call it their own. Mount Hood. Oregon's tallest peak, 11,237 feet.

And while they may ski your slopes, windsurf in your shadows, scale your summits, camp on your earth, and fish your rivers, there are still places where you, where I, can be at peace. Birds flock to your trees, lakes hug your shores, rainbows of bright color dapple your hillsides. Cow elk come to calve; a pair of sandhill cranes, mated for life, come to nest at Salmon River Meadows.

How many faces can a mountain have? Can it have a morning face to thousands skittering under its grace or clip-clopping along under its trees? Can it stand benign and let me be the first to touch the virgin

■ Left: *Mount Hood N.F. Appropriately named, the White River's color is a combination of glacial silt and sand. In midwinter with subzero temperatures, the river creates intricate ice patterns in sweeping, undulating forms. The White River plain is a popular nordic ski area on the south flank of Mount Hood.*

snow, to leave my tracks and breath in the glitter of the air? Can it have a gentle face while I ice-skate on Trillium Lake, before the skiers come, when it is my rink, my sky, my mountain. Then I will turn it over to wood ducks and ring-necked ducks, to the marshes and the summer.

Perhaps its broadest face is Timberline, where you can ski down its flanks; sleep in its lodge . . . handsome, historic, hand carved; climb to its top under a full moon, come home in the day under a blue sky. In the summer, hike its trail clear around, past waterfalls and glaciers, canyons and forests. Its rugged face is the north side . . . still wild, pristine, and lonesome. Winds howl up Ghost Ridge, climbers challenge Cathedral. An alpine glow of orange, pink, and yellow draws the sun down on the west face. The smell of sunshine and huckleberries hangs in the air. Lush meadows blanket the east face, dotted with ponderosa pines and lodgepole, downhill and cross-country

skiers, and—by late spring—taken over by orchids and avalanche lilies.

This was a mountain named to honor a man, Rear Admiral Sir Samuel Hood of the British Navy. It has become a mountain, that has become a forest, that honors a people, who—quite unabashedly—love it.

Columbia Gorge. Lava made it. Water carved it. Life grew on it. At its feet rolls the indomitable Columbia River; on its sheer rock sides spill perhaps the largest concentration of high waterfalls in North America, twenty or more of them plunging through space; its face is covered with moss, old-growth Douglas-fir, and wildflowers. You are in the Columbia Gorge, and water falls from everywhere, out of crevices and canyons, over walls and cliffs, from the fogs that hug its hillsides, from the rains that wash it green. Feel its power echo inside your skull as you stand behind Tunnel Falls or Upper Horsetail. Watch from a narrow bridge as Multnomah plunges 620 feet down. Bathe me in your mists. Silence me in your sound. Bed me in your forests.

A dipper bird, who does springy little knee bends on the rocks, begs you to follow him through a shallow creek, up a winding cleft in the canyon walls. Licorice fern and lichen drip over the sides. Sunlight splits the air of Oneonta Gorge.

Bleeding hearts and coltsfoot, bead lilies and woodland violets, Johnny-jump-ups and white trillium lead you past Herman to Whiskey Creek, up into noble and silver fir. It is April, and when the high Cascade meadows are still buried beneath the snow, the Gorge is already blooming. Over eight hundred species of native flowers grow here, some only found clinging to cliffs or pushing past rocks. In May, purple calypso orchids. In June, blue delphinium.

Feel the wind lick your face clean as you stand on Chinidere Mountain and feast your eyes on the sights: the towering, untamed north side of Mount Hood; the snow-shrouded peaks of Rainier, Adams, Saint Helens; the sprawling Columbia; the vast wheat fields of eastern Oregon; and at your feet a sea of red Indian paintbrush.

You may have this beauty served to you in a hundred ways. You can drive it, walk it, hike it. You can get lost in its solitude. You can picnic in its smile. You can love this place with a young heart, with an old heart, with memories, or with dreams.

■ *Above:* Mount Hood N.F. Plans for Timberline Lodge were developed in 1927, and the W.P.A. project became a reality under the direction of E. S. Griffith. The Forest Service holds tours and historical presentations year-round. ■ *Right:* Mount Hood N.F. Ramona Falls is a one hundred-foot cascade over black rock and moss. The trail follows the Sandy River, crosses the Pacific Crest Trail, then continues up through alpine terrain and rock to Yocum Ridge on the west side of Mount Hood.

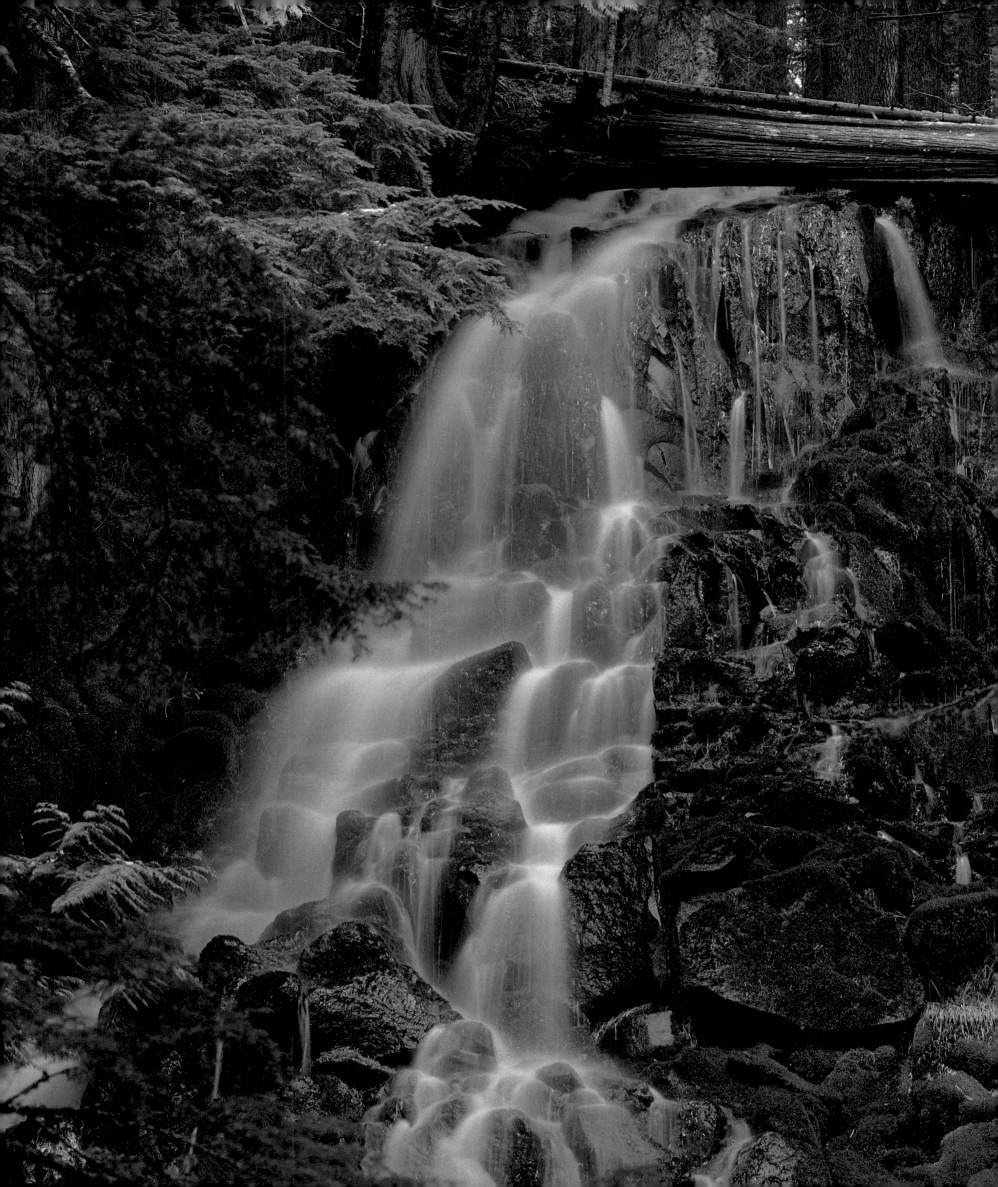

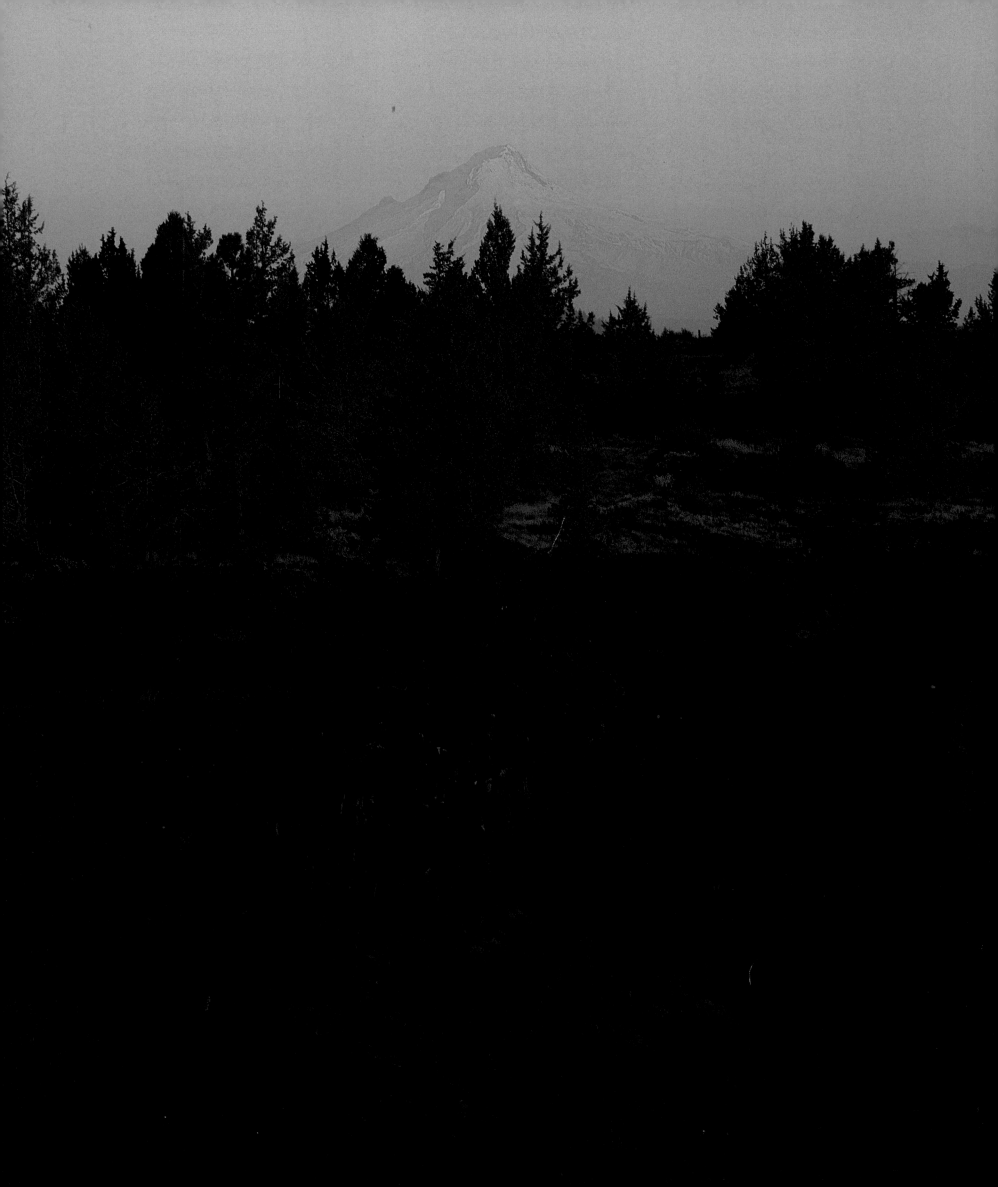

This forest is a mountain. And this mountain is a beauty. And at its feet are a people who call it their own.

■ *Left:* Mount Hood N.F. Across Mill Creek Gorge—on land of the Warm Springs Confederated Tribes—to the slopes of Mount Hood, Highway 26 transects the northwest forest past juniper on the high plain, lodge-pole pine, ponderosa pine, intermingled pine and fir, mixed fir with cedar, then Douglas-fir shading lacey vine maple. ■ *Above:* Mount Hood N.F. Conifers and noble fir thrive on the south side of Mount Hood. The noble fir is the largest native true fir in North America.

*You are in the
Columbia Gorge,
and water falls
from everywhere,
out of crevices and
canyons, over walls
and cliffs. . . .*

■ *Above:* Mount Hood NF. Indian paintbrush and myriad other wild-
flower species are found along the banks of Tilly Jane Creek. Tilly Jane
was the nickname of Mrs. William S. Ladd, who summered at nearby
Cloud Cap Inn. ■ *Right:* Mount Hood NF. Named for W. R. McCord
who built fish wheels on it, McCord Creek drops down Elowah Falls into
a chasm, then twists around boulder, cliff, and tree to the Columbia River.

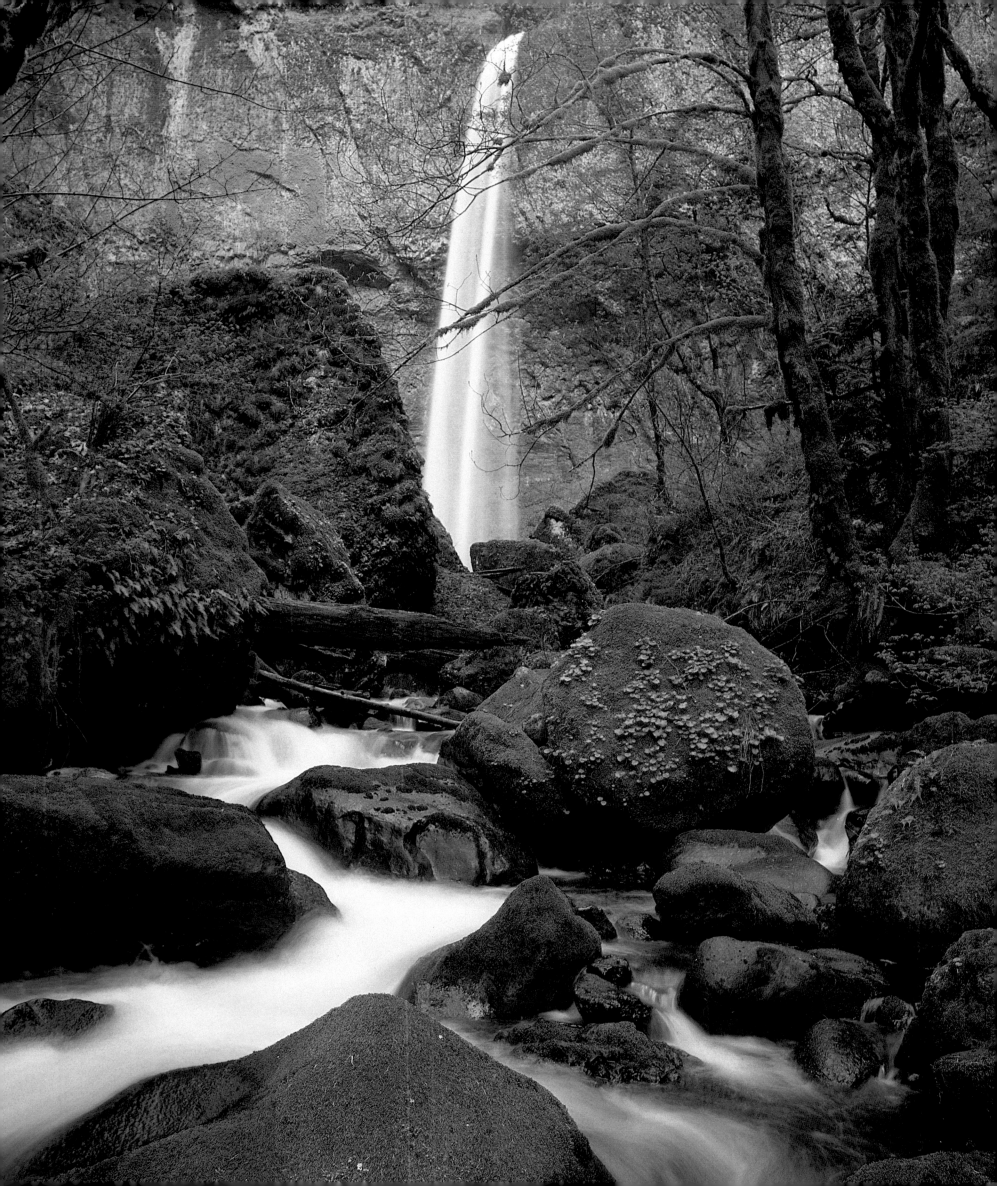

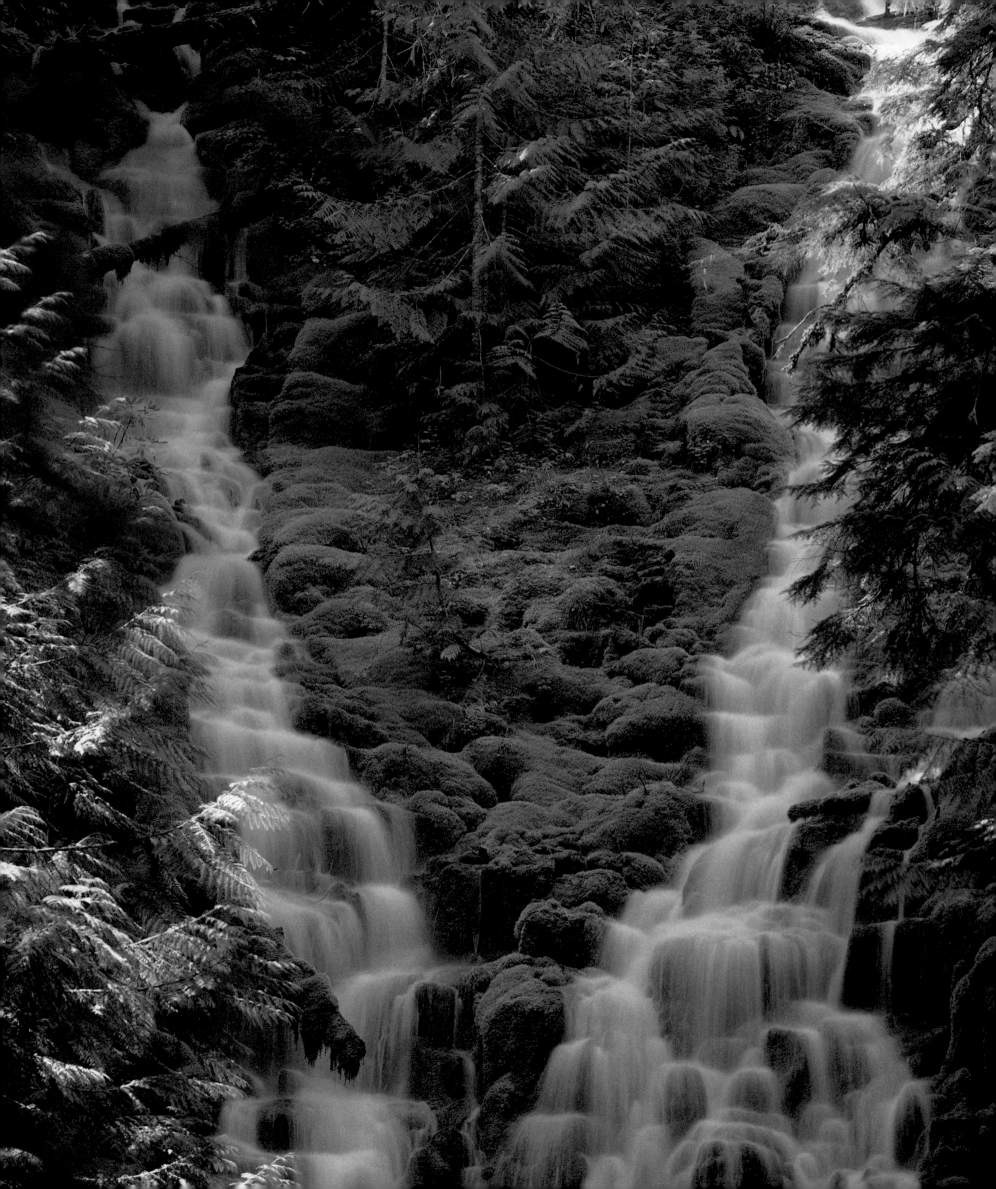

DESCHUTES

DESCHUTES · Fire and ice. Glaciers and volcanoes. Hot springs and cold rivers gurgle out of the earth. Pine sap tickles your nose. Blue sky wipes your eyes clean. Yellow-bellied ponderosas make room, and you walk. White-powdered mountains touch openness; your mind runs for it. Stars have space to stretch out; lakes have pockets to hide in.

The Deschutes. A forest that is named for the river, *La Rivière des Chutes,* meaning "River of the Falls." Another river rises here, the icy Metolius. You wade in, cast your own fly on the riffles and are nourished not so much by the rainbow trout, but by this pristine land that makes the spirit soar.

August. An orange-and-black tortoise shell butterfly follows you as you climb toward Broken Top in the Three Sisters Wilderness. A volcanic savagery carved

■ Left: *Willamette NF. In the Three Sisters Wilderness, Proxy Shadow Creek cascades through a narrow channel of rocks and moss. To the north, the forest disappears in the huge lava bed surrounding Belknap Crater.* ■ Overleaf: *Deschutes NF. Lava Butte is the northernmost vent of eight found along the northwest rift zone of the Newberry Volcano.*

your view, leaving behind ice sculptures and crevasses. Whitebark pine and mountain hemlock dot the slopes. A Clark's nutcracker screams. The rare pumice grapefern grows underfoot. You can taste the solitude, feel the fires that once raged here. Morning fog wraps around old snags at Crane Prairie Reservoir. Ospreys nest in the trees. Trout feed in the waters. Lodgepole pine rims the shore. A baited line sinks silently down.

A blink of an eye, a geologic eye, 1,350 years ago, you might have seen a Paiute Indian on a vision quest up Paulina Peak. While he sought his spirit God, he could see all the way from Mount Rainier in the north to Shasta in the south, from the Ochocos in the east to the Cascades in the west. Paulina and East lakes lay before him. Today you can stand at Newberry Crater, the largest volcano in the Northwest, and feel the past in your bones, see it in the lava. Deep underground geothermal waters burst to the surface. A volcano tells your feet, "I am alive." A bald eagle circles.

A stone's throw away, on another day, in another time, on another mountain, skiers slice through the fabled Bachelor powder. Laughter lingers. Fire and ice and the smell of pines. Deschutes, you are my forest.

WILLAMETTE · The smell is cool, damp, refreshing; the feeling, enveloping. Underfoot is a sense of decay, of life renewing itself. Overhead, sun filters down, slanting through dense canopy. Massive, thick Douglas-firs, western hemlock. Elk come in winter for thermal cover. Delicate white princess pine comes later for ground cover. Rain falls. Different from city rain. Thick, dense fir needles let it come softly to your face. Quieting. Water runs everywhere—rivulets, creeks, streams—over moss and rock, collecting in lakes and marshes. The Willamette National Forest is named for the river the Indians called the *Wal-lamt,* "spill water," referring to the falls near Oregon City.

Wilderness and solitude are here. Its feet covered by lava flows, Mount Washington is sometimes called the "Black Wilderness." Let your toes touch the moon. Know how small you are. The Menagerie, rock spire remnants of the Old Cascades. Walk through madrone and golden chinquapin; test your fantasies against the rocks they call "the Porpoise," "the Bridge," "the Turkey Monster." Breakfast in a bed of wildflowers on the side of Three Fingered Jack. For lunch, leave your shoes along the banks of an alpine lake, one of hundreds. Cold. Let go. Later, hike the meadows of Mount Jefferson through fields of red Indian paintbrush. Cross the ridges where sweet-smelling white beargrass spills over the sides. Black bear eat its succulent roots. Indians wove baskets from its leaves.

Miles away, a caddis fly hatch brings the McKenzie River redsides glittering to the sun. A nesting pair of harlequin ducks rise as you glide by in your wood-bottomed river boat. A mink slips down the bank under the big leaf maple and disappears. Home perhaps. This forest is home to so much: Opal Pool, Falls, Creek—jewels, sheer gems in the heart of old-growth red cedars and Douglas-firs. Know that your roots run deep.

Rain clouds rush up the tree-filled foothills of the Cascades. You are sitting in a meadow, by the natural pools at Breitenbush Hot Springs. Night falls around you. Winter comes later as you glide cross-country toward Midnight Lake. The forest hangs her whiteness out. At home with it all.

WILLAMETTE

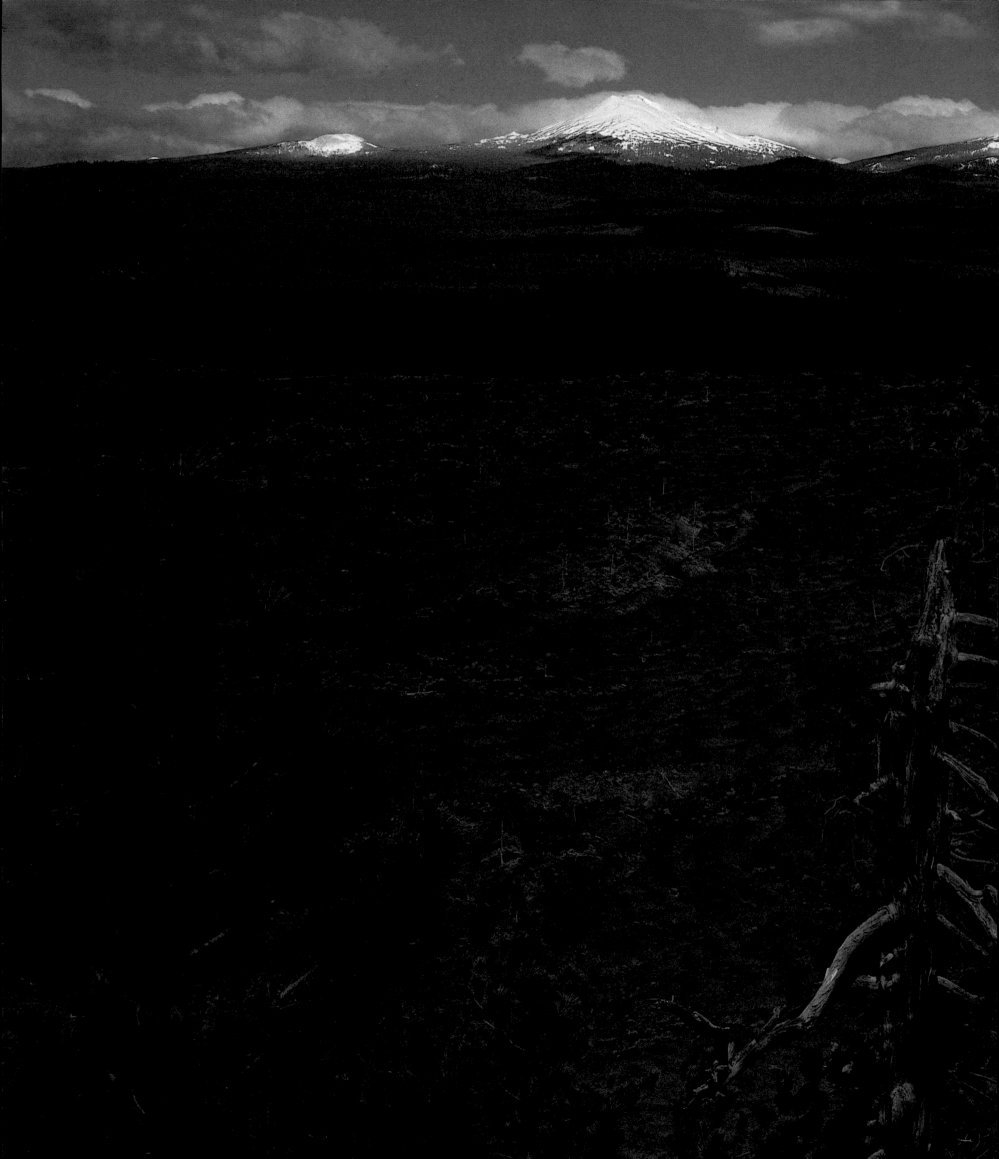

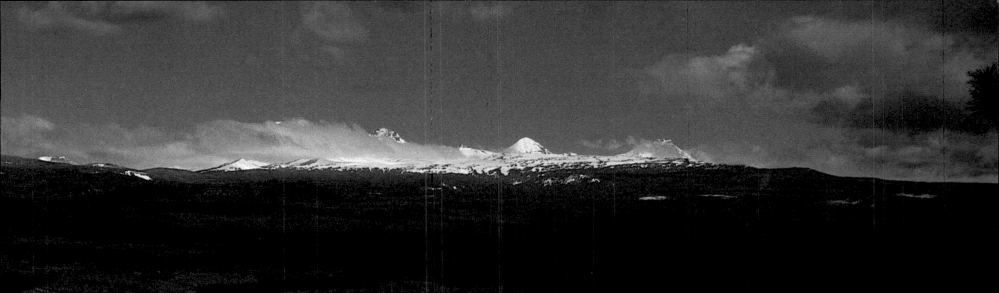

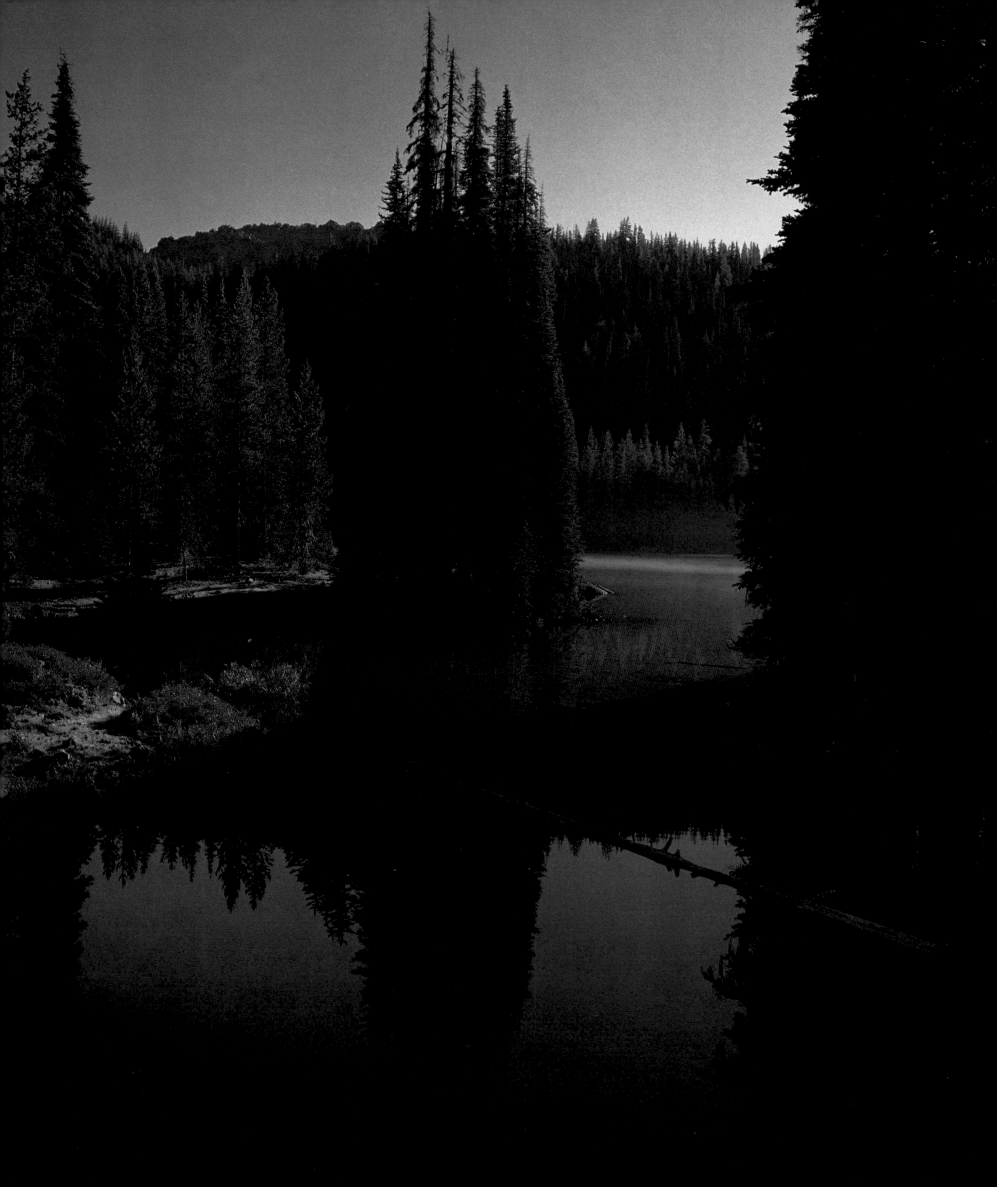

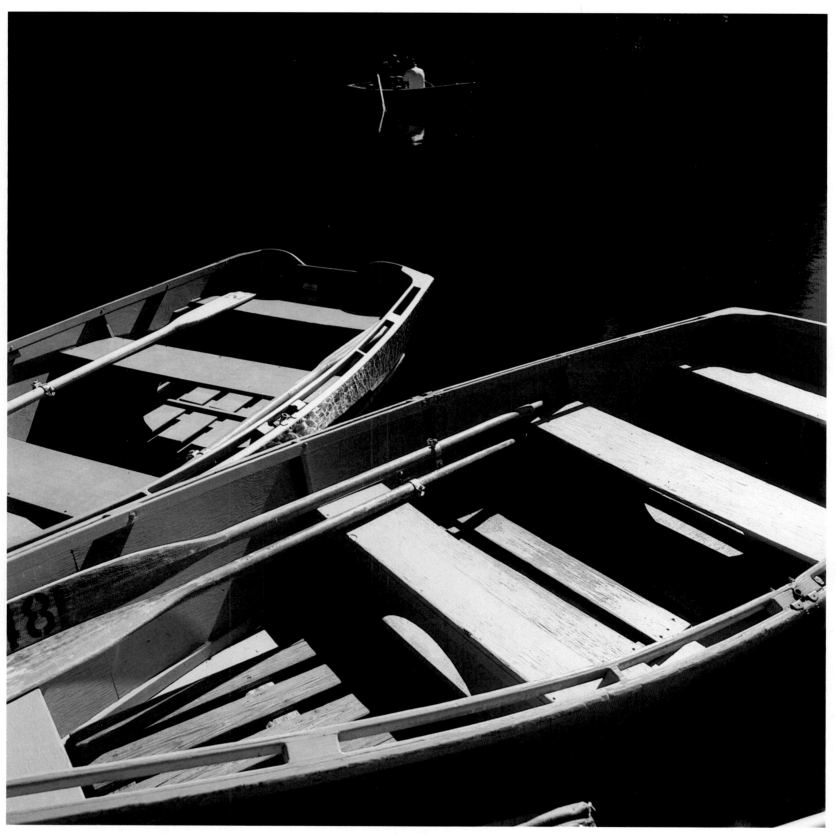

■ *Left:* Deschutes NF. Trees that seem created by a magician's hand, the forest's deep green, and the water's emerald green enchant as the warmth of the summer sun causes the mist to rise from the lake. Devil's Lake borders the Three Sisters Wilderness. ■ *Above:* Willamette NF. Visitors may rent a row boat for a quiet morning of fishing or dreaming on Clear Lake. While many lakes boast a multitude of resorts with canoes and rowboats, a hike into other lakes nearby offers greater solitude.

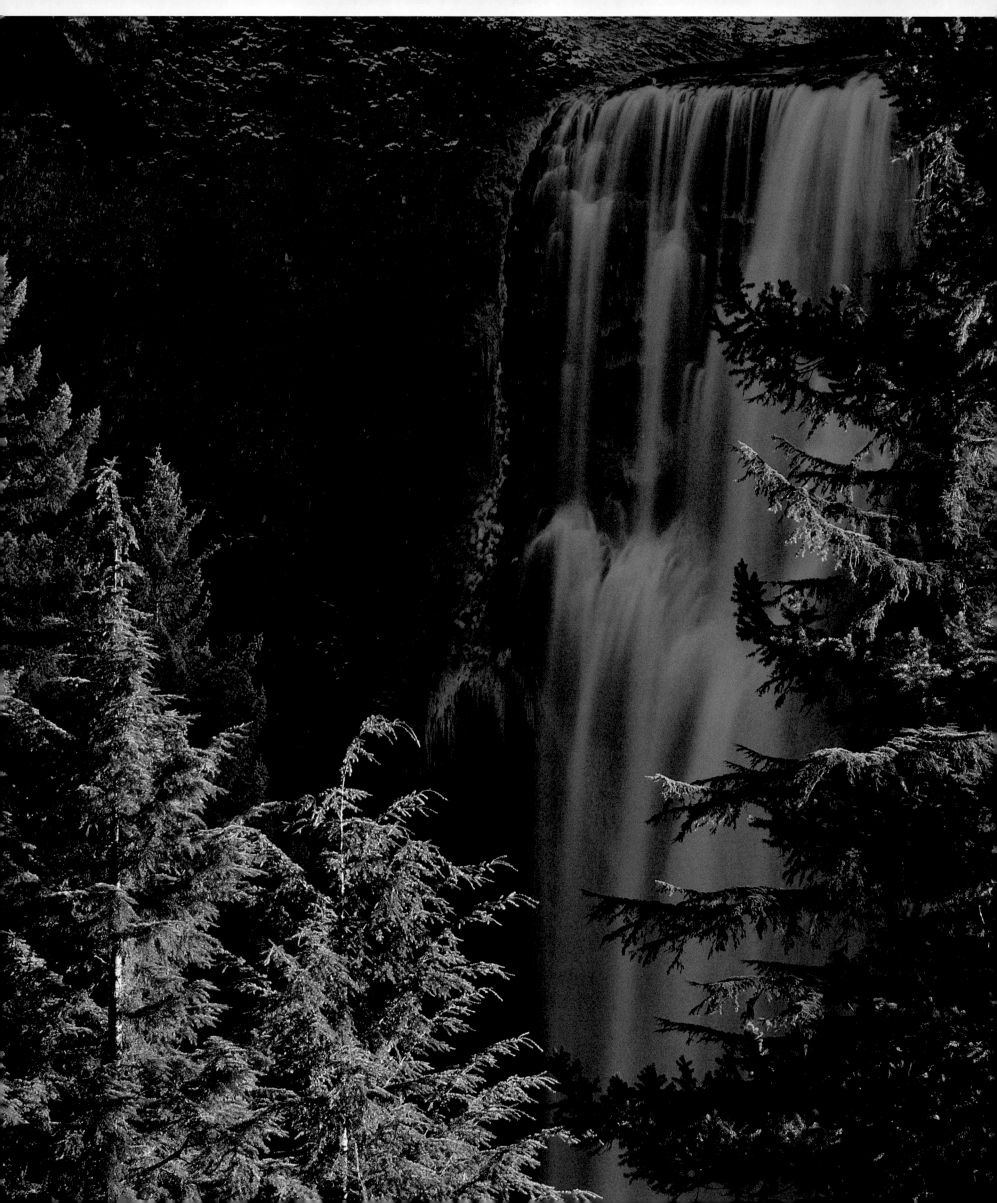

Cross the ridges where sweet-smelling white beargrass spills over the sides.

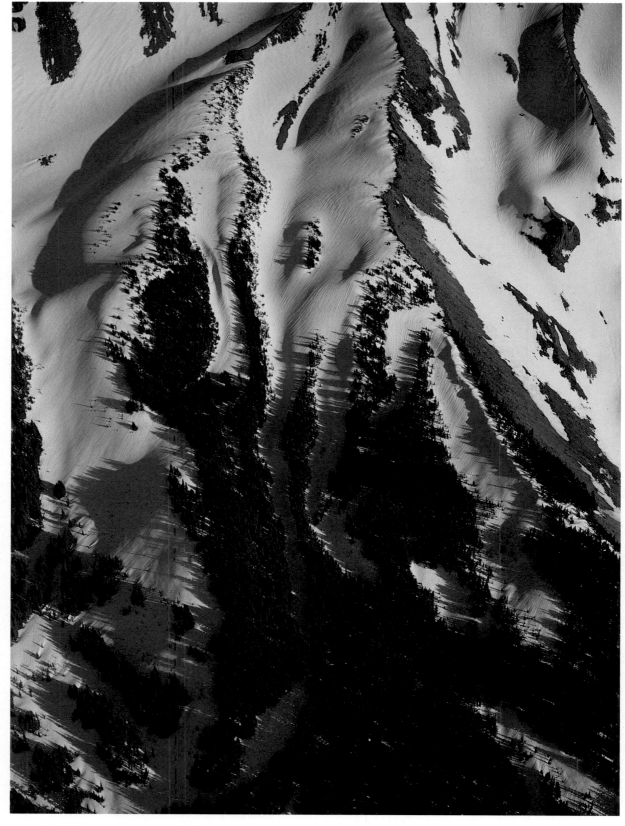

■ *Left:* Willamette NF. Named for salt springs found along the stream, Salt Creek, a major tributary to the middle fork of the Willamette River, plunges nearly three hundred feet into a ravine. ■ *Above:* Willamette NF and Deschutes NF. Along a ridge on the west flank of Mount Jefferson, 10,497 feet, intricate patterns in the snow may have been formed by rain showers and melting snow alternating with freezing. The Mount Jefferson Wilderness encompasses 193.6 miles of trail within its 111,177 acres.

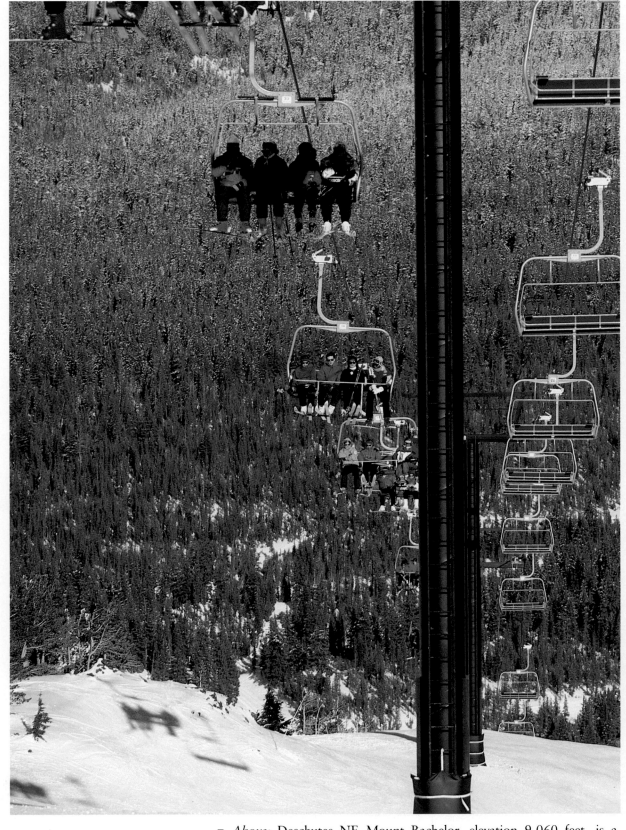

Fire and ice. Glaciers and volcanoes. Hot springs and cold rivers gurgle out of the earth.

■ *Above:* Deschutes NF. Mount Bachelor, elevation 9,060 feet, is a world-class premier alpine and nordic ski area known for its excellent dry powder snow and its magnificent scenic qualities. Previously called Brother Jonathan in deference to the Three Sisters, Mount Bachelor is a young mountain, as geologists count age, with no glaciation erosion.

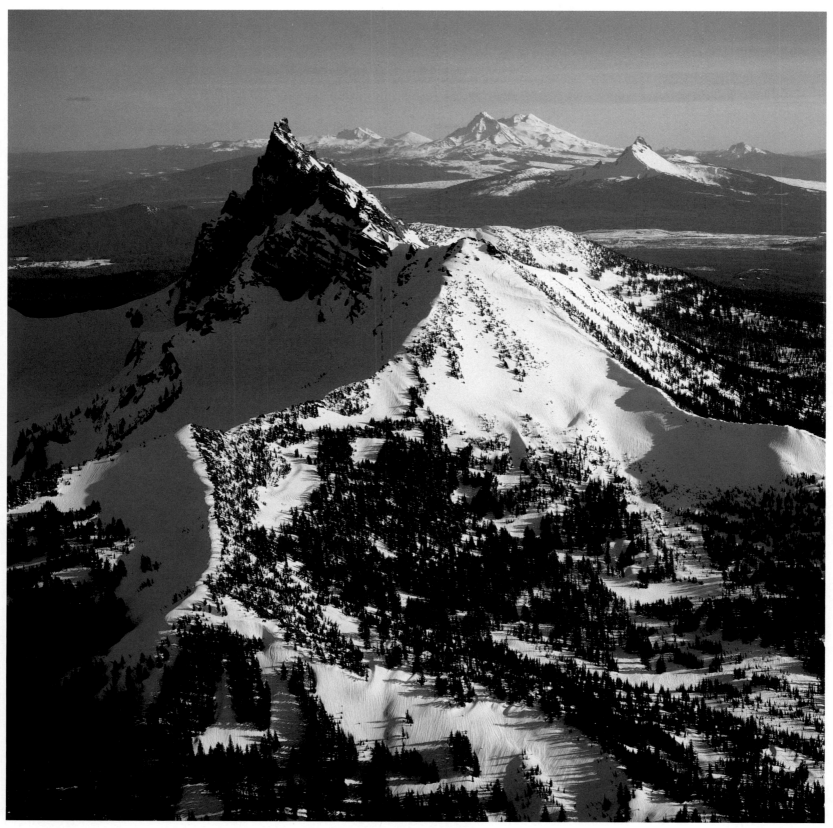

■ *Above:* Willamette NF and Deschutes NF. Each facet of Three Fingered Jack, in the Mount Jefferson Wilderness, is different. A needle point from the north, it looks like a Himalayan peak from the west. First named Marion, it is said the present name stems from a three-fingered trapper named Jack, who lived nearby. Its 7,848-foot peak has three rocky spires.

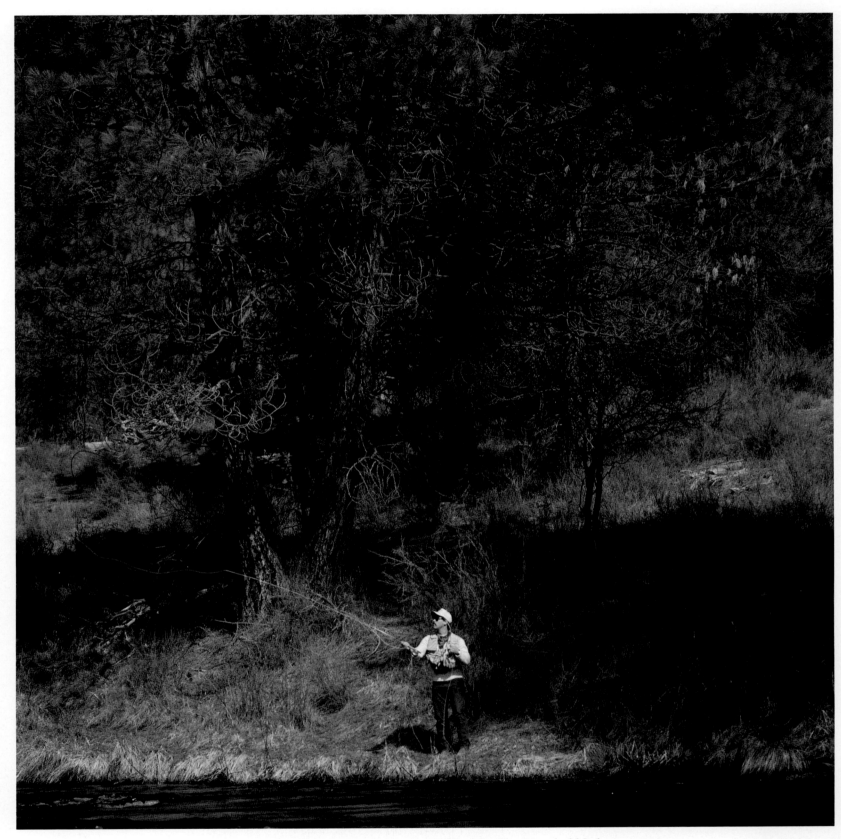

■ *Above:* Deschutes NF. Clear waters of the Metolius River bubble from a large spring flowing from the north base of Black Butte. The Metolius provides some of Oregon's finest fly-fishing. ■ *Right:* Deschutes NF. The waters of the Metolius River boil through a deep hole at Wizard Falls Hatchery. The color of the water changes briefly from green to ice blue.

OCHOCO

OCHOCO · *Ochoco* is the Indian word meaning "willows," a land of accessible solitude. A land not dominated by craggy peaks but by giant, yellow-bellied ponderosa pine with bark that looks like crocodile skin, little jigsaw puzzles in your hand. The ground underneath, rolling fields of grass cleared by centuries of fire. This is a place of subtle surprises, like the vast grasslands that cover thousands of acres cut by canyons and streams, juniper and sage, springs and seeps, creeks and meadows—wildlife meccas in the summertime. You circle a dot on the map where cottonwoods, aspen and willows, where mock orange, alder, and red osier dogwood gather. It is early morning at Willow Creek. Everything that walks or flies comes here to drink with the dawn. Elk dip their heads; swallows skim the air; horned larks feed their young; beavers

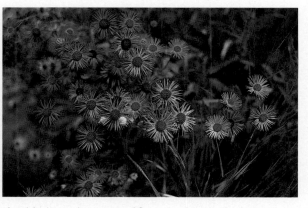

■ Left: *Malheur NF. The autumn sun rises where high prairie meets the Strawberry Mountains' north face. The mountains, at an elevation of 9,052 feet, are the highest point in the southeast Blue Mountain Range. The name was derived from the wild strawberries that were found along the banks of a creek to the north.*

build their dam; windflowers, bluebells, and lupine cover hillsides; redwing blackbirds sing water songs; kestrels and coyotes wait. You can make a list, or you can watch and listen.

Another place. The cry of a stallion on Lookout Mountain. A roaming band of wild horses stare you down, hear his warning, wheel, and disappear into the magnificent old-growth ponderosas. The antelope, too, are there, deep in the timber. Why are they here and not out on the plains where they should be? No answer, just wild horses and antelope, and the late afternoon smell of pines. Delicate. Warm. Elusive. Leaves you hungry for more. Breathe.

But the Ochocos haven't finished with you as the trees open into Big Summit Prairie. You whistle with vultures and range cows and memories of settlers who cleared this land, then died and left it. A few poplars and orchards remain where cabins once stood. A long ways now between people.

Shift again. Steins Pillar, a single volcanic plug, four hundred feet high. You scale it—fingers, toes, chest, and chin inching up.

Others hunt thunder eggs, jasper, and agate; scratch the soil; drive mosquitoes away; sweating, they share the sandstone with red ants and lizards. In the wintertime, bald eagles roost high in the trees, lumbering out of the pines at daylight, over the fields of Post and Paulina. Accessible solitude, these Ochocos. A land of subtle surprises.

MALHEUR · Dawn. You are already five thousand feet up, your breath ices as it falls out of your mouth. A bull elk slices the air with his incessant breeding bugle. Fall creeps on little feet as a yellow-pine chipmunk looks for your breakfast cereal. With the last taste of coffee swirling around in your mouth, Strawberry Mountain slips out of view. You follow elk across the ridge, down a fir-shrouded slope toward a grove of larch waving their amber needles in the autumn winds of morning. Bighorn sheep on Canyon Mountain could care less as they chew their cud on a rocky ledge, shadowed now and then by a red-tailed hawk hunting for a canyon mouse who may forget for one fleeting moment what flies overhead.

The Malheur—a forest who got its name from the river, and the river who got its name from the trader, Peter Skene Ogden, who called it *Riviére au Malheur,* "River of Misfortune," because furs had been hidden there, then stolen by Natives. So who are you, Malheur, stealer of dreams, a forest lived on by bear, bobcat, and mule deer; headwaters to the Silves, the Malheur, and most of the John Day rivers; home to rainbow, cutthroat, redband; to spring-run chinook and mountain whitefish? Who are you who rises out of the seemingly-but-never-barren desert floor of silver sage, squirreltail and bluebunch grasses, where the Ord's kangaroo rat lives for months without water? Leave it behind. Walk up toward Vinegar Hill through the ponderosa, lodgepole, and Englemann spruce, past springs and deserted mining camps to pockets of yellow buckwheat and white angelicas.

Then the season shifts. The snows arrive, powdery. You stand on skis, sunbaked. Logan Valley spills out in front of you, untouched except for one set of tracks, paws perhaps, looking for food. Who is here in this silence? "And who are you, Malheur, and why should I spend my days here?"

MALHEUR

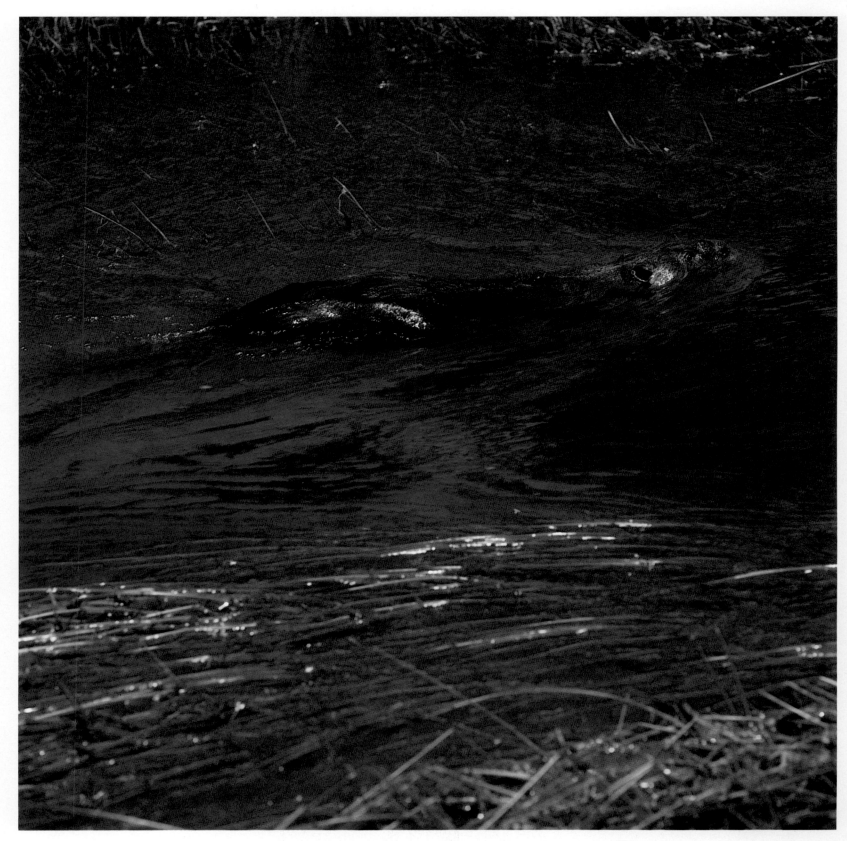

■ *Above:* Ochoco NF. Beaver dams are an integral facet of the grasslands' riparian environment. Willow Creek winds through the shallow gorge protecting its fragile plant life. ■ *Right:* Malheur NF. The trail to Road's End at the Strawberry Wilderness south entrance climbs over High Lake Rim down into High Lake, past Strawberry Falls and Strawberry Lake. Strawberry Wilderness maintains 150 miles of trail in its 68,300 acres. Rabbit, bighorn sheep, and Rocky Mountain elk leave tracks in the snow.

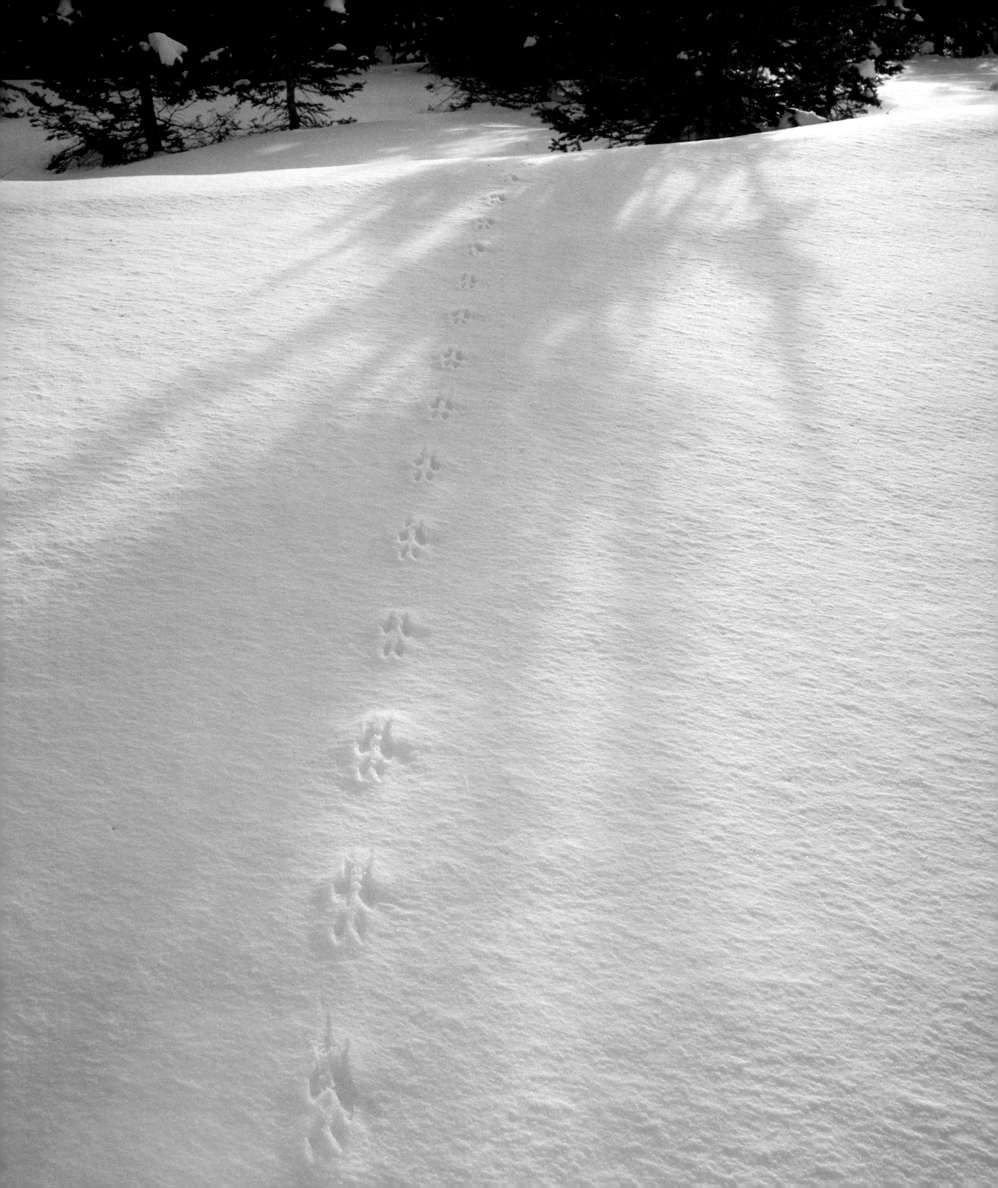

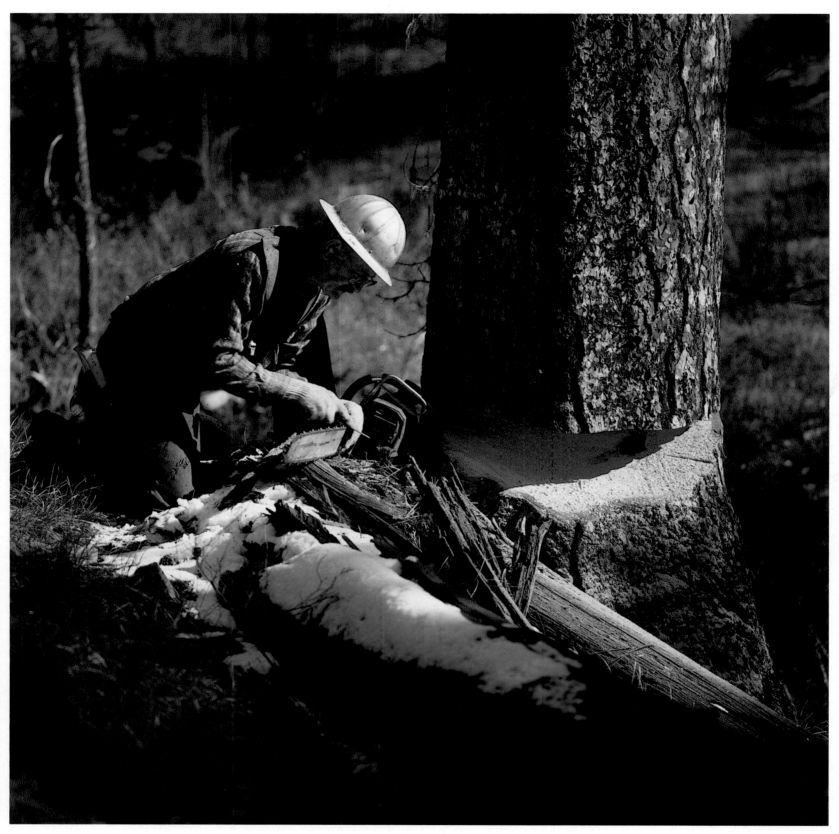

■ *Left:* Malheur NF. Prevalent in the Malheur, the western larch or tamarack often survives or follows forest fires. It protects and is later overwhelmed by other conifers. The western larch's yellow orange needles signal the beginning of winter. ■ *Above:* Malheur NF. A faller sharpens his saw beside a ponderosa pine he has undercut. This tree was felled in a selective cut to avoid damage to neighboring twenty- and thirty-year-old pines. Weeks later, the tree was helicoptered to a hauling site.

It is early morning at Willow Creek. Everything that walks or flies comes here to drink with the dawn.

■ *Above:* Ochoco NF. Along Willow Creek is a glimpse of the grasslands area history: petroglyphs and pictographs of faces or animals scrawled on stone, the narrow road which supported the stagecoach line, and a nearby homestead fruit orchard. ■ *Right:* Ochoco NF. Dammed at the headwaters of Camp Creek, Walton Lake appears to have always been there.

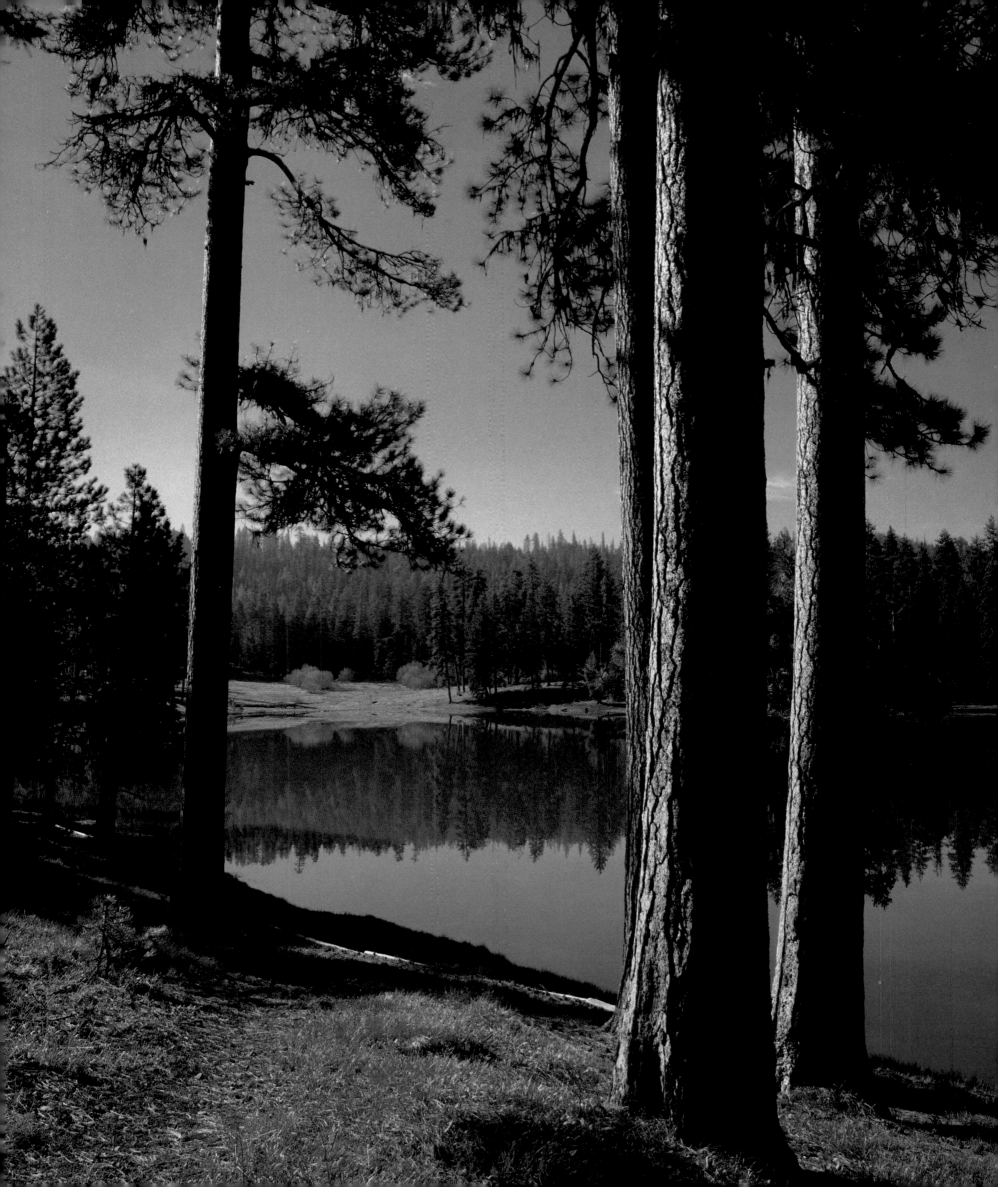

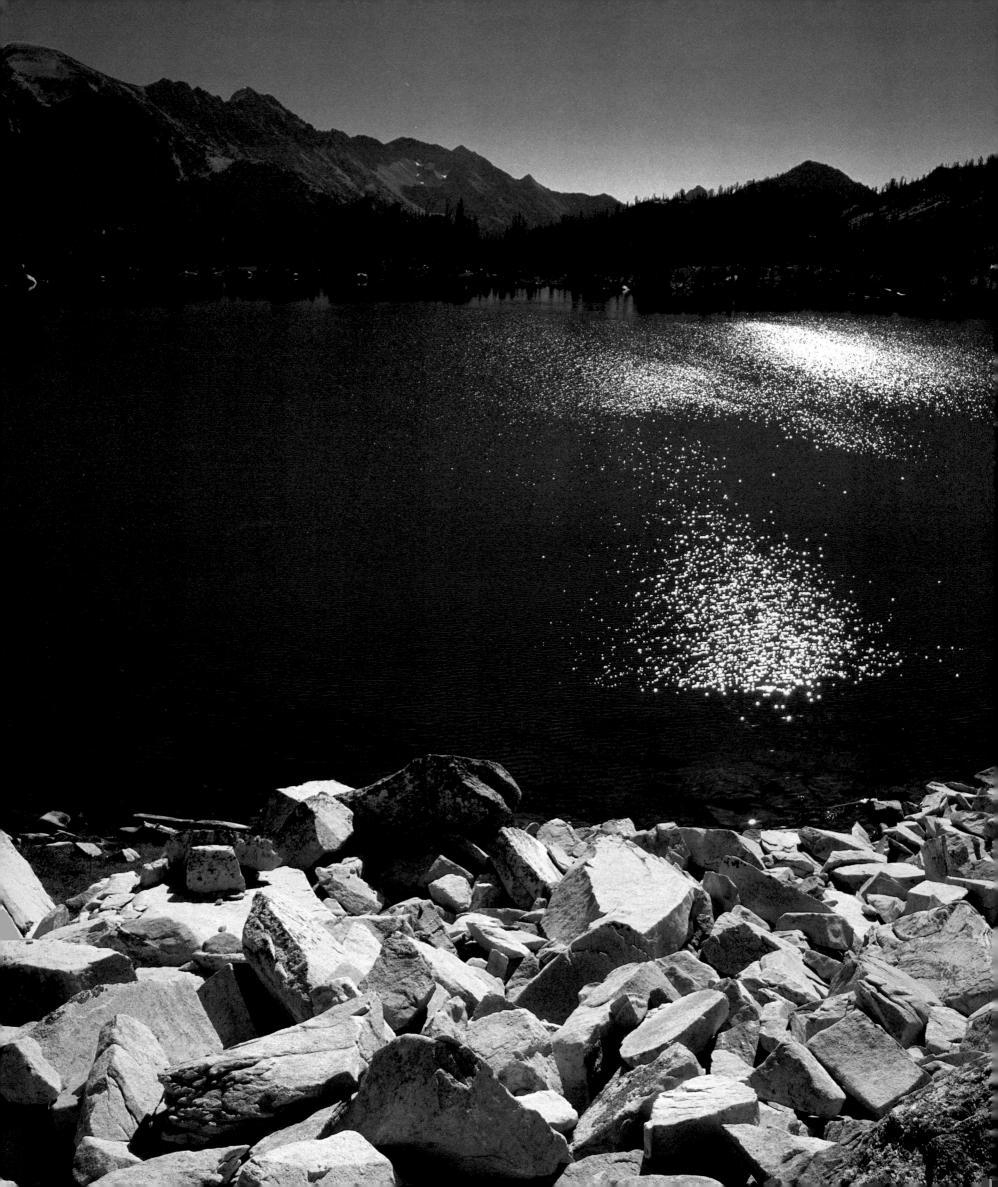

UMATILLA

UMATILLA · With one foot you stand on dry, rocky ground; with the other foot, you stand in a deep, green grotto, water all around. Go ahead, look out over these Blue Mountains. Remember the canyon you just walked out of, where Shimmiehorn Creek lives dense with licorice and maidenhair fern, black cottonwood and yew, water dripping from the sheer basalt cliffs. Remember wild ginger and phantom orchids, yellow warblers and red-eyed vireos. Remember only fleetingly the office walls you left behind. Now, peace.

Umatilla: Some say it is an Indian word for river, some say it means "water rippling over sand." It is a place of stark contrasts, of upside-down mountains and deep, forested canyons, of brawling streams and still ponds, of grasslands on top and arbors on the bottom. A land once home to Nez Perce, Cayuse, and

■ Left: *Wallowa-Whitman NF. The sparkle of white granite surrounds Blue Lake, which lies high in Eagle Cap Wilderness. Rock formations here are granitic, not volcanic, in origin, a phenomenon unique in the Northwest. During the Pleistocene epoch, the Wallowa Mountains were likely glaciated at least three times.*

Umatilla tribes. A land that tried to hold the settlers back, but unrelentingly they winched their wagons up to the tablelands, then spilled down the Oregon Trail. Elk live here, the largest gathering anywhere in the country. A blue grouse squawks over your ankles. Steelhead and chinook come a long way home to spawn. In the spring, hillsides are a dazzling blanket of food—pink Douglas onion, blue camas, yellow balsam root—an edible painting. Farther south on the Greenhorns are high alpine lakes, meadows, streams.

But it is a moment you want—the smell of junipers; the cold breeze blowing as you ice-fish on Bull Prairie Lake. Hike up a rocky slope past a whistling marmot, wade through miles of mountain monardella, a purple mint flower that leaves its fragrance on you. Rise early on a summer morning at Jubilee Lake, watch the elk drink, hear the pileated woodpecker drum the trees for breakfast, edge your boat through the reeds, let your line trail. Not a mile off, a two-foot-high golden

lupine grows, the sabin, found only here in these Blue Mountains. Stark contrasts, this Umatilla.

WALLOWA-WHITMAN · Plain and simple, this is one of the most mystical, powerful, God-filled places on earth. If you are looking for your soul, you will find it here. Want to pit yourself against nature, try it on this Eagle Cap Mountain, in this canyon called Hell, in this river called the Snake.

Stand on a craggy, windswept ridge with bunchgrass slapping at the sun and look into the deepest canyon in North America, Hells Canyon. Feel something wild, peaceful, unspoken. Feel the layers of yourself being peeled back as you traverse through whitebark pine, spruce, subalpine fir, across spring-fed creeks, around rock ledges, down to the bottom where the Snake River hurtles between canyon walls. There are many hells here. The shacks abandoned by the settlers could tell about a few; great Chief Joseph, chased by the Blue Coats could tell you more. Bighorn sheep, cougar, bear, elk live here. Aspen and cottonwoods. Rattlesnakes and cactus. Magpies screech in the air. Giant white sturgeons up to twelve feet long swim the milky, emerald waters. Downriver, rafters plunge through Wild Sheep Rapids. Treacherous. Intoxicating.

Limber Jim Meadows in the Blue Mountains, surrounded by old-growth white fir, larch, Englemann spruce. Call in the great gray owls, watch dragonflies eat their weight a day in mosquitoes, catch glimpses of goshawks, see a cow elk standing in lush spring grass.

Stunned, look up at the Wallowa Mountains, seventeen mountains over nine thousand feet tall. The Matterhorn, with its eighteen hundred-foot shimmering marble cliff; Sacajawea, where the spike-horned mountain goats live. Here are lakes and meadows by the hundreds—heather, lodgepole pine, Douglas-fir, and bluebells. At timberline grows limber pine, found nowhere else in Oregon. If you camp, hang your food out of reach of black bears. If you fish, keep the handle of your pole away from porcupines who might chew it for salt. But isn't this why you came to the Wallowa-Whitman? Wallowa, a Nez Perce word, *lacallas;* a structure of stakes for catching fish. And Whitman, for Marcus Whitman, the pioneer missionary who in 1836 brought the first wagon over what became the Oregon Trail.

Wallowa-Whitman, a place where the road does end, and you can begin.

WALLOWA·
WHITMAN

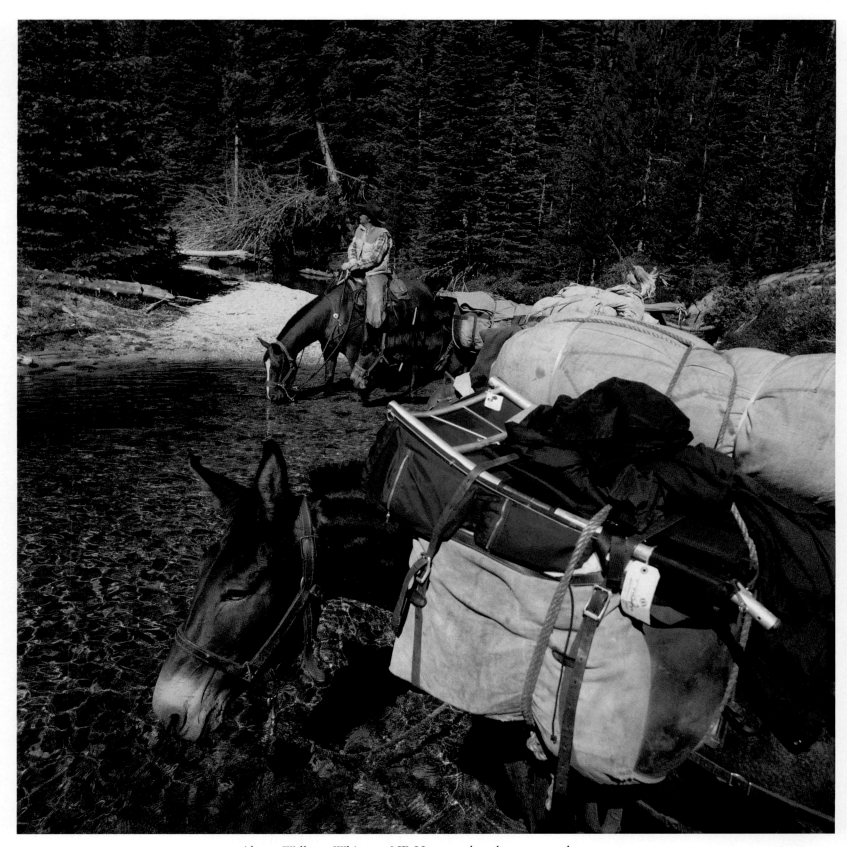

■ *Above:* Wallowa-Whitman N.F. Horse and mule teams pack campers and supplies to a site in the Eagle Cap Wilderness. The pack team is watering at a trail crossing of the Lostine River. There are thirty-four thousand acres of land in the Eagle Cap Wilderness which support important populations of bighorn sheep, elk, bear, cougar, and bobcat.

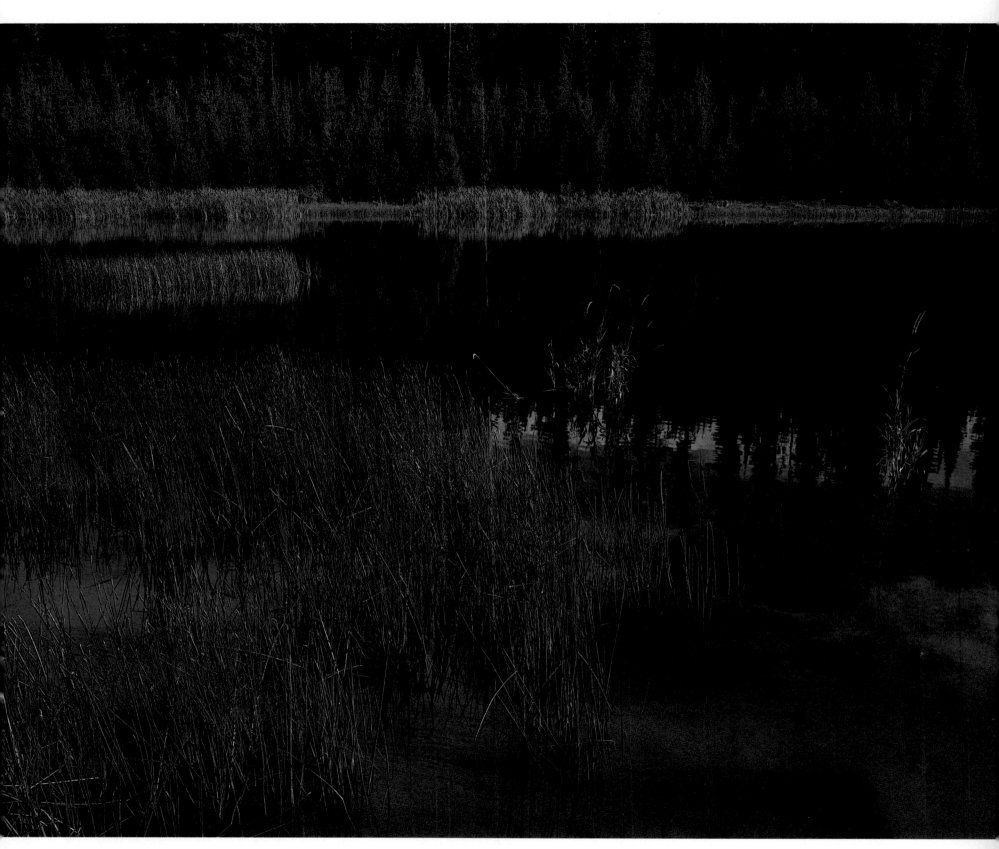

■ *Above:* Umatilla NF. Cattails line the shores of Jubilee Lake, a popular recreation area at the northern tip of Oregon near the Wenaha-Tucannon Wilderness. The Umatilla National Forest blankets the Blue Mountains with seven hundred miles of trails maintained by the Forest Service and twenty-five campgrounds. This forest covers 1,402,482 acres of land.

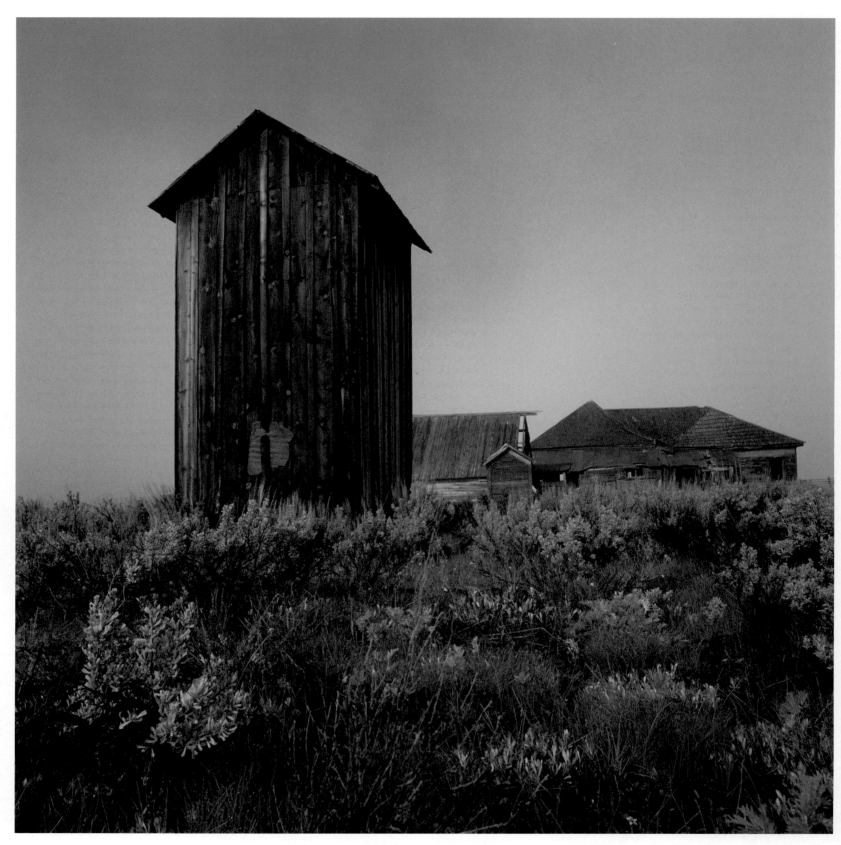

■ *Above:* Wallowa-Whitman NF. Whitney boasted a lumbermill and a small gauge railway during gold rush days in Eastern Oregon. In the mountains, remnants of the gold rush are found in ghost towns such as Bourne, Greenhorn, and Granite. ■ *Right:* Wallowa-Whitman NF. Minam Lake, in Eagle Cap Wilderness, is unique, as it is the origin of two streams. From the north shore flows the Lostine River, and from its south shore flows the Minam River. *E-mi-ne-mah* was the area's Indian name.

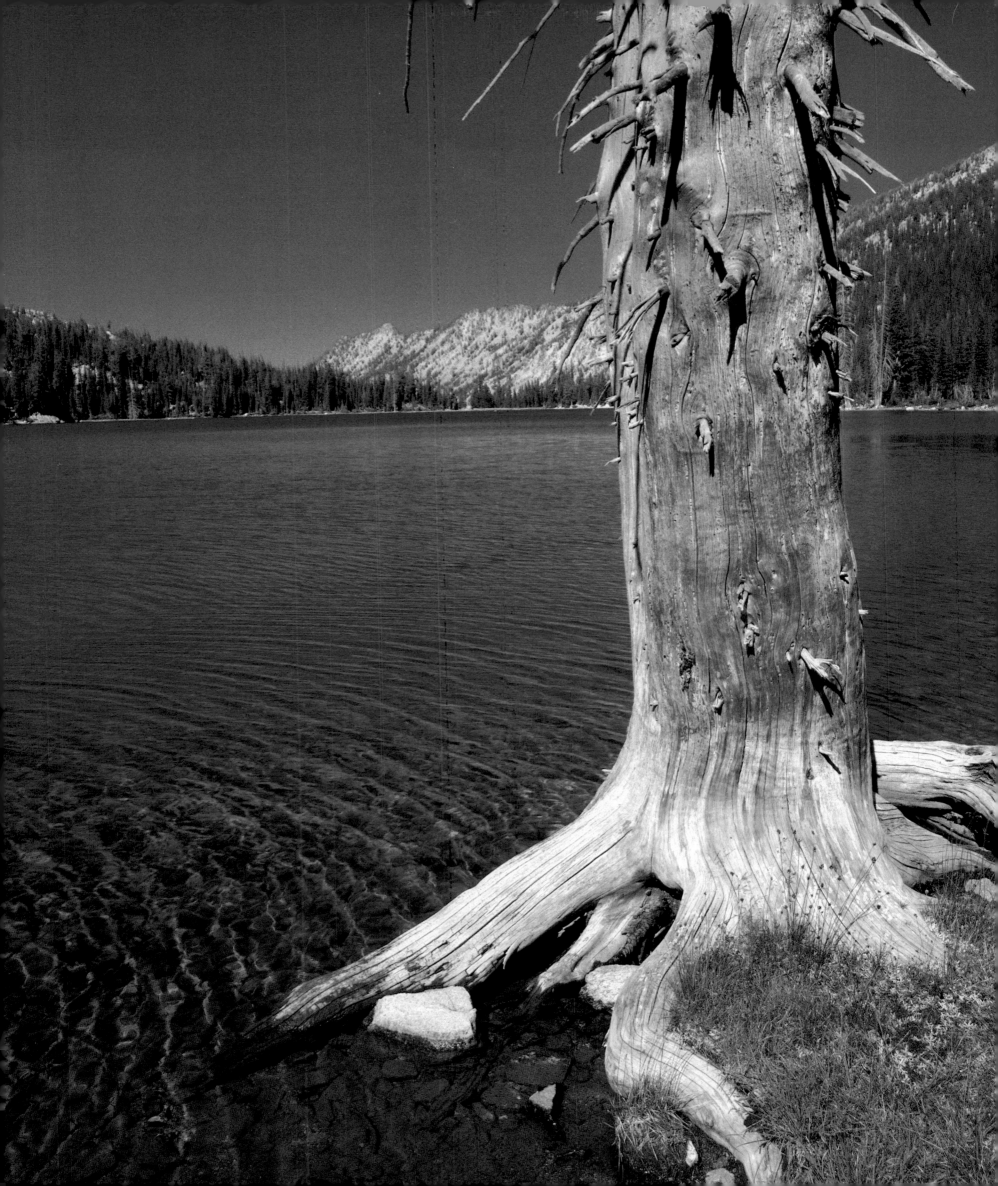

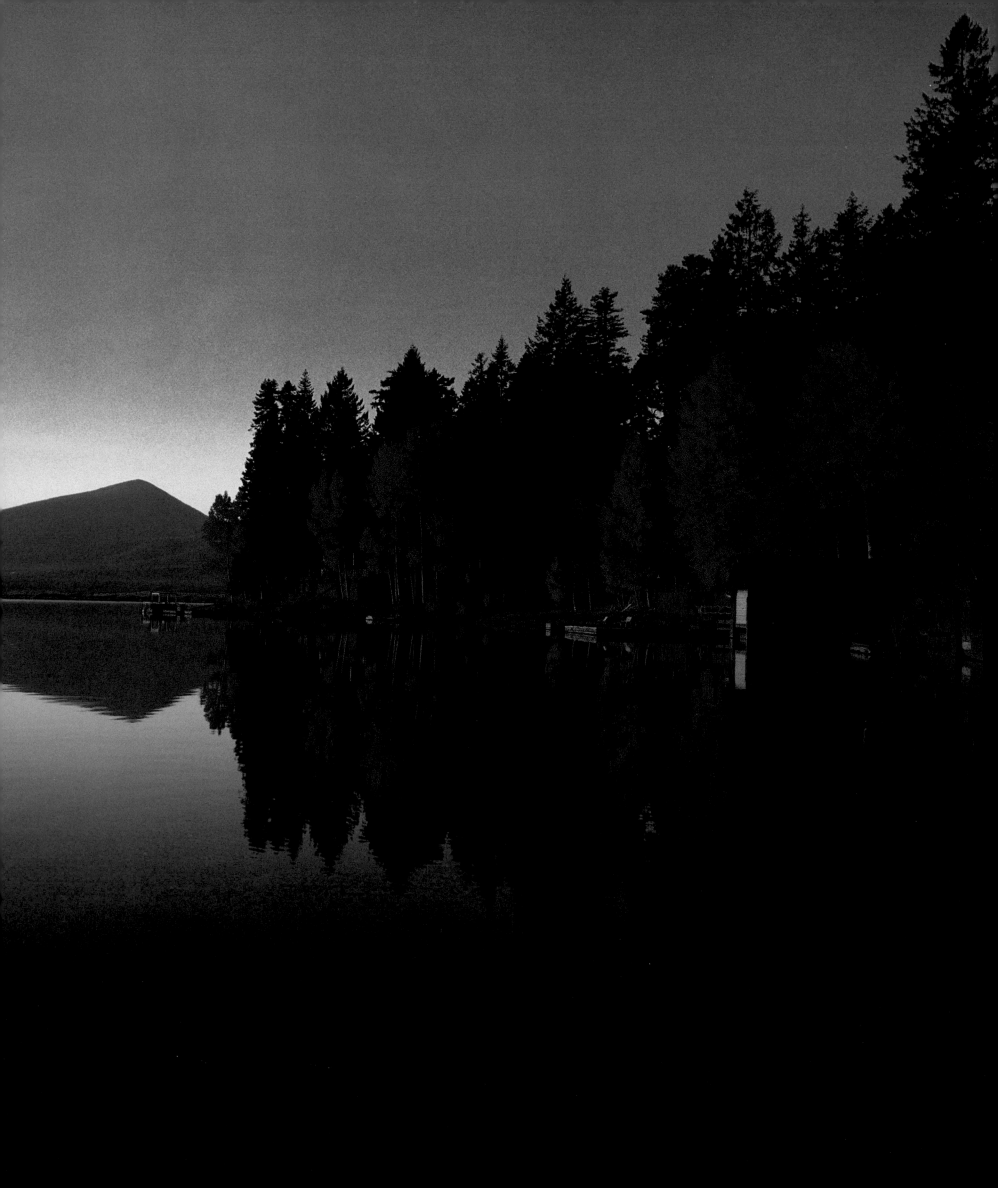

WINEMA

WINEMA · You are in a holy land. This ground, these marshes, these lakes, these mountains all held a people together—the Klamath people, the *Ouxkanee,* "People of the Marsh." The ducks and geese, owls and eagles, coyotes and deer, beaver and bear were their food, their spirits. They nourished the body, the soul. Lean back against a flat rock here on Pelican Butte. Look out to Upper Klamath Lake, Mounts Shasta and Thielsen, vast marshes and grain fields. By your feet is a vision quest cairn, a small group of rocks ten inches high. They have sat here for thousands of years, here where a young *Gu'Mbotkni* boy came to fast, to dance, to pray, to sing a lonely song. He came to find his guardian spirit in the Winema, where 85 percent of the known vision quest cairns in the world are found. Touch your past. It lingers in the longing cry

of the sandhill cranes. *Winema,* meaning "Woman of a Brave Heart."

Push your canoe out at Malone Springs through a watercolor of apple green rushes and dark green reeds, yellow water lilies and red-necked grebes, a blue sky canvas colored with cinnamon teals and black terns on silver wings.

Or take to the Sky Lakes, Mountain Lakes, Lake-of-the-Woods, hundreds of lakes. Stand on a volcanic rim two million years old. Gnarled and twisted whitebark pine flaunts its weathered limbs to the wind. Below a basin of dark blue lakes lying in a bed of droopy mountain hemlock and lodgepole pine.

Miles away, seven sacred springs rise from a pumice-strewn hillside. The Williamson is born. A meadow of yellow daisies and blue lupine pulls you down to lunch on spicy watercress, sweet smells, egg-blue sky.

Winter sky. Eagle sky. Bald eagles fly. Over four hundred fifty, the largest massing in the lower 48.

Let a spinner dive, tease the Kokanee, alone at Miller Lake. But the marshes draw you back, primitive, pure. Klamath Forest National Wildlife Refuge. Muskrats build houses, geese nest on their roofs, white pelicans fish the waters. Life is here by the hundreds, by the hundreds of thousands. The air, the earth are alive. You are alive.

FREMONT · Ride back in time. Let your mind run with the jackrabbits. Lope your horse up one draw then another, through pretty aspens and little creeks, across meadows and canyons, up into those yellow-bellies, to the rimrocks and valleys below. Hawks and giant blue sky keep you company.

You are in the Fremont National Forest. And yesterday is very much today. This is tranquil, unpretentious country. There is the spare beauty of the desert, with its grays, greens, speckles of spring colors. There are sheer cliffs, naked rocks, towering ridges. The lushness of the forest: cinnamon trunks of sugar pines, pumpkin-colored bark of ponderosas, gray alligator of white pines. And there is more aspen splashing the hillside with buckets of orange and yellow than in any forest around. There are large concentrations of the soft-eyed, big-eared mule deer. But no hot tubs in fancy campgrounds, no glitz, no glitter. You take it as is. Maybe that is why you won't see people for days.

Try Coleman and Dead Horse rims. Move through meadows until you are in the midst of the oldest, biggest, most extraordinary old-growth ponderosas in Oregon. Acre upon acre. The smell of vanilla.

Farther north, on a winter day with snows as deep as a horse's belly, his men frozen, John Frémont rode to what felt like the edge of the earth. A thousand feet down, like a mirage, was a huge lake fringed with grass, the valley beyond. It was December 16, 1843. He named the spot Winter Ridge; the land below, Summer Lake. And this forest became the Fremont.

Large-mouth bass and yellow perch lure you to Dog Lake. A symphony of sound—Canada geese, western grebes, coots, and yellow-headed blackbirds. Watch the silent drifts of gold-flecked pollon weave their way around the marshes.

Or float the Sycan River in April, down rimrock canyons, watching prairie falcons. Alone. Hang glide off Abert Rim, the nation's tallest geologic fault. Fall free through blue sky. Free.

■ Left: *Winema NF. A fall sunrise saturates both the aspen trees and summer homes; Mount Harriman is visible in the distance. Originally christened Pelican, Rocky Point was established in 1888 as a recreation area. The Point is on Pelican Bay's west shore, on Upper Klamath Lake.*

FREMONT

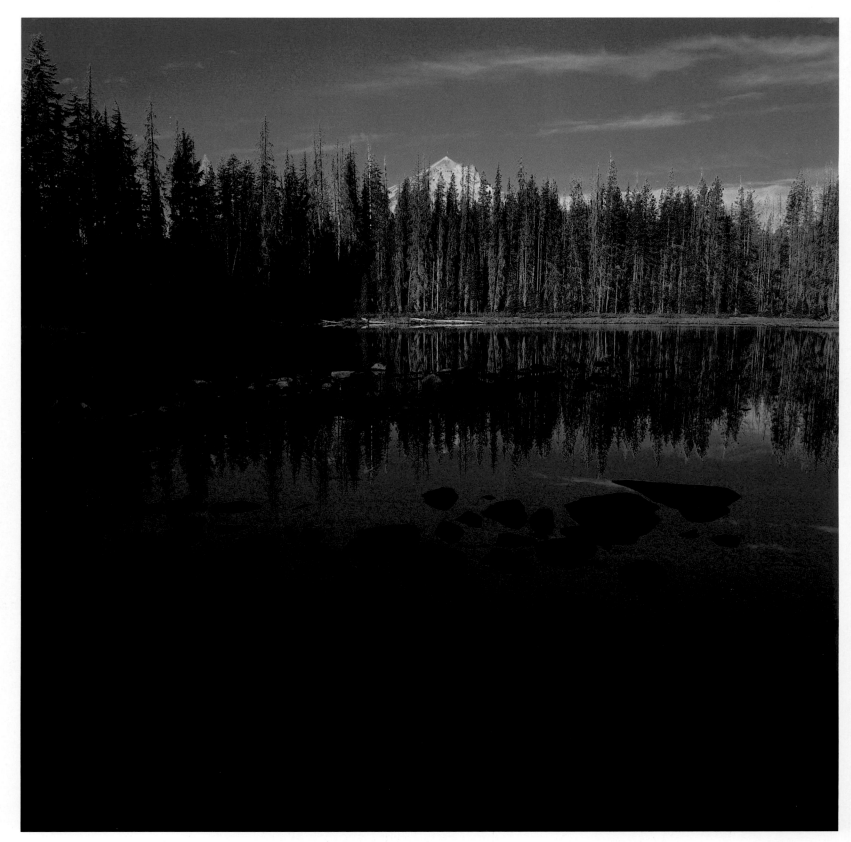

■ *Above:* Winema NF. The Winema includes Sky Lakes and Mountain Lakes Wilderness, and Lake Berniece lies between, along with numerous ponds. The ponds seem tranquil until myriad ducks—alarmed—rise in unison. Once named Mount Pit for the pits dug by Indians to trap game, Mount McLoughlin, 9,495 feet, dominates Oregon's Southern Cascades.

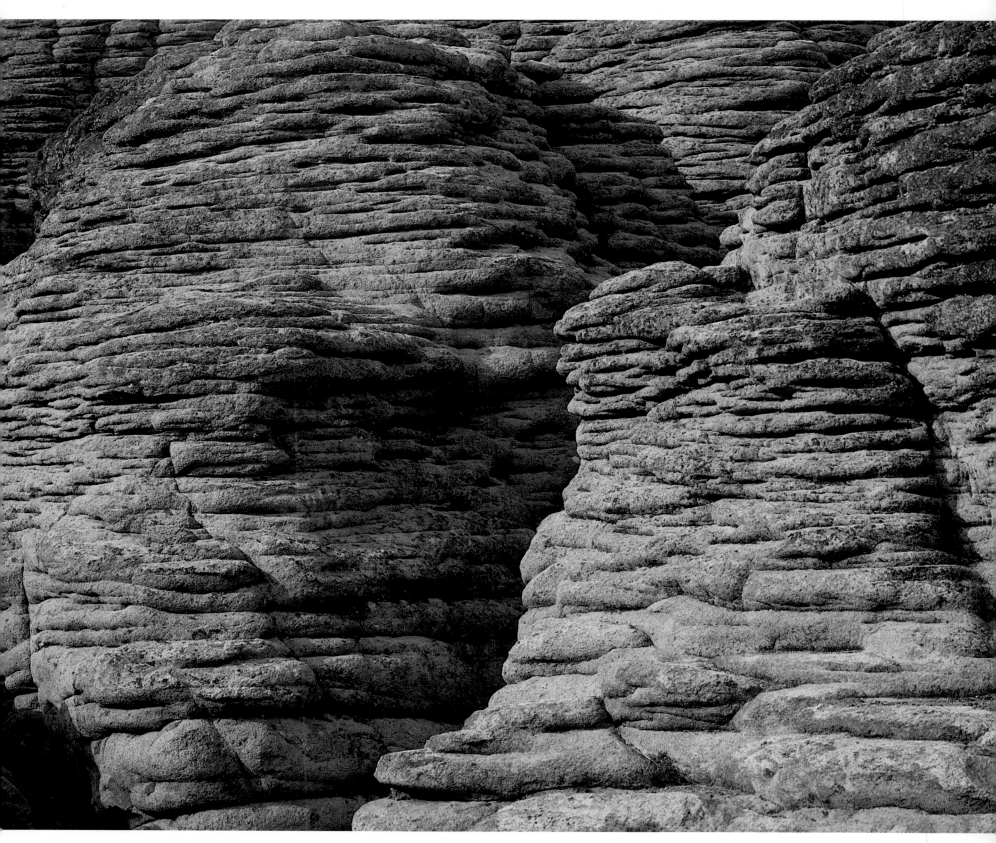

■ *Above:* Fremont NF. Flows of massive porphyritic lava from a nearby volcano have produced fascinating rock formations at Palisades and at the Dome in the Gearhart Mountain Wilderness. *Porphyritic* means "owning distinct crystals." Established in 1964 with 22,823 acres, the Gearhart Mountain Wilderness maintains seventeen miles of trail inside its borders.

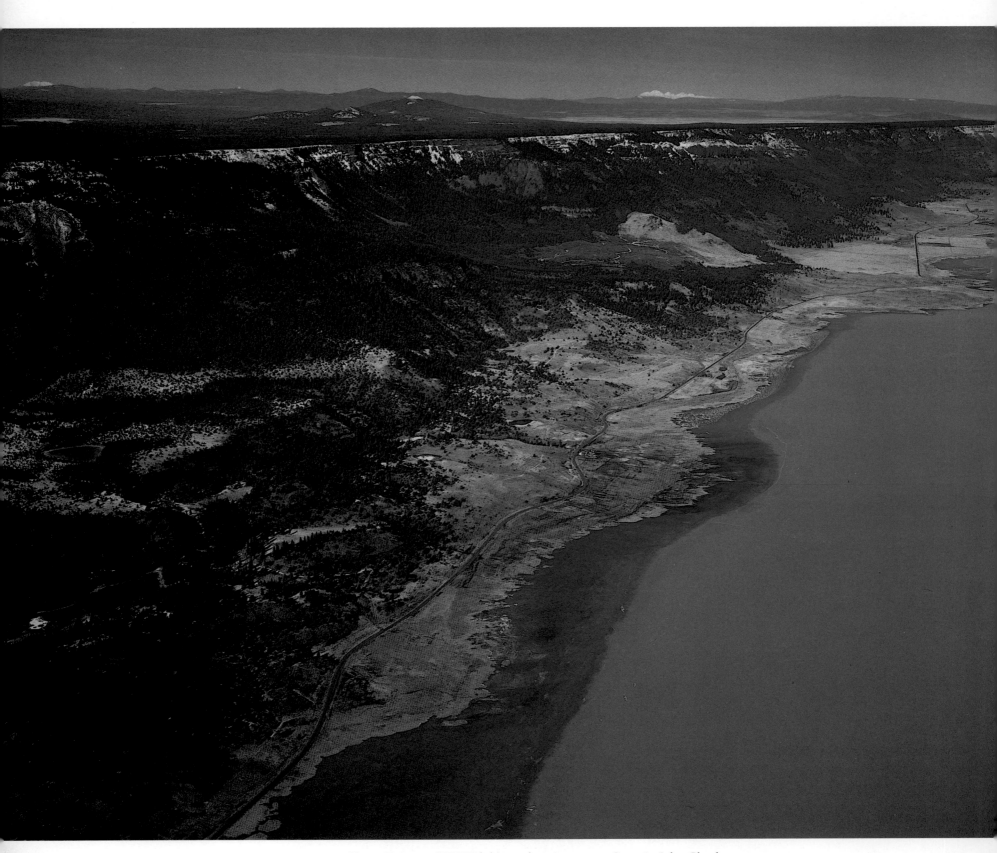

■ *Above:* Fremont NF. With his exploration party, Captain John Charles Frémont endured the bitter cold and deep snows at the summit of a rimrock ridge in the winter of 1843-44. As he gazed upon the green meadows and beautiful lake below, he named the summit Winter Ridge; the inviting lake, clearly visible yet so far out of reach, Summer Lake.

There are sheer cliffs, naked rocks, towering ridges. The lushness of the forest. . . .

■ *Above:* Fremont NF. Quaking aspen, which is found in both the Fremont and Winema forests, derives its name from the shimmer of leaves with only a whisper of wind. The quaking aspen provides sustenance for numerous wildlife—deer and elk, beaver and rabbit, grouse and quail. ■ *Overleaf:* Winema NF. Fourmile Lake was named for its length.

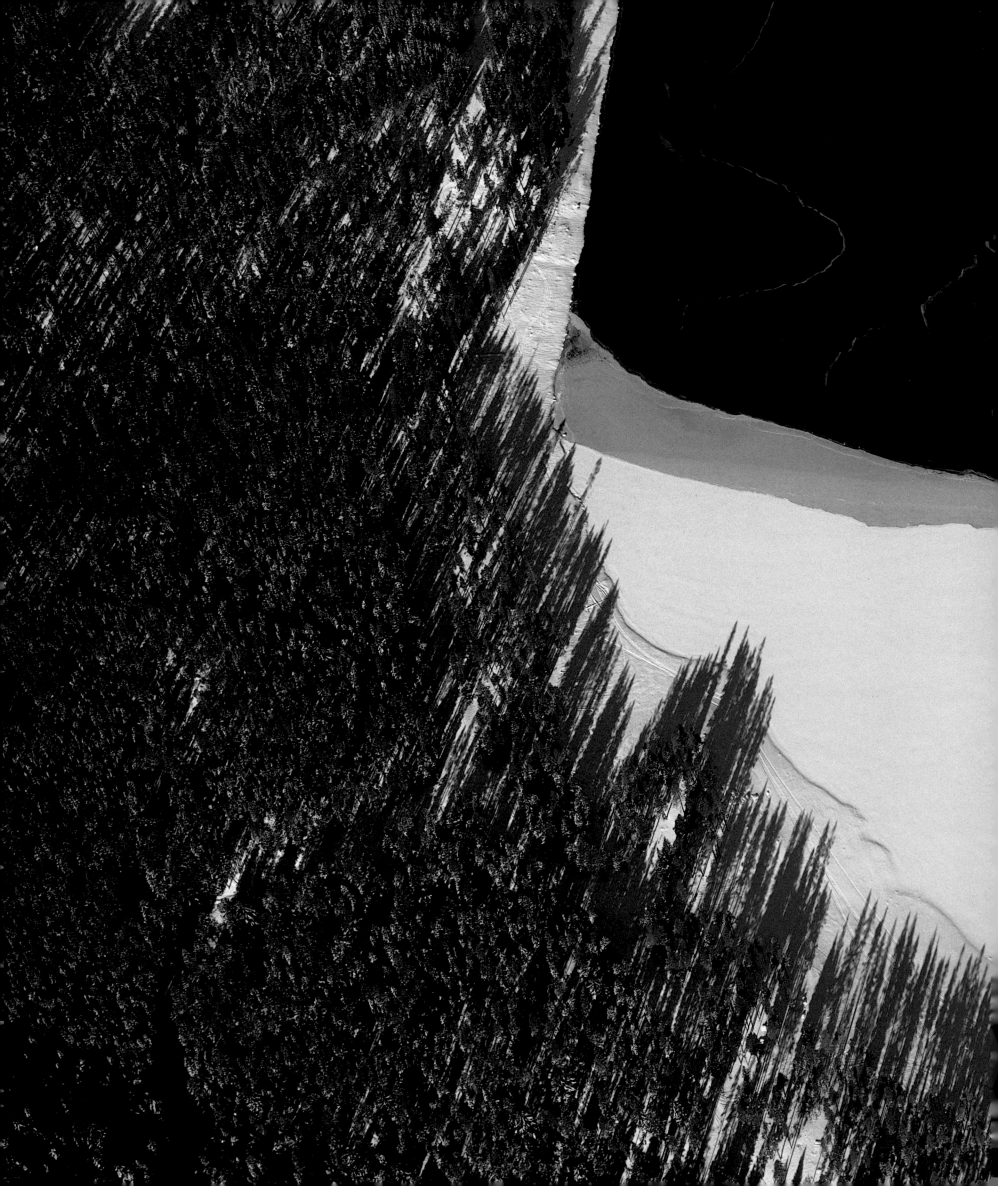

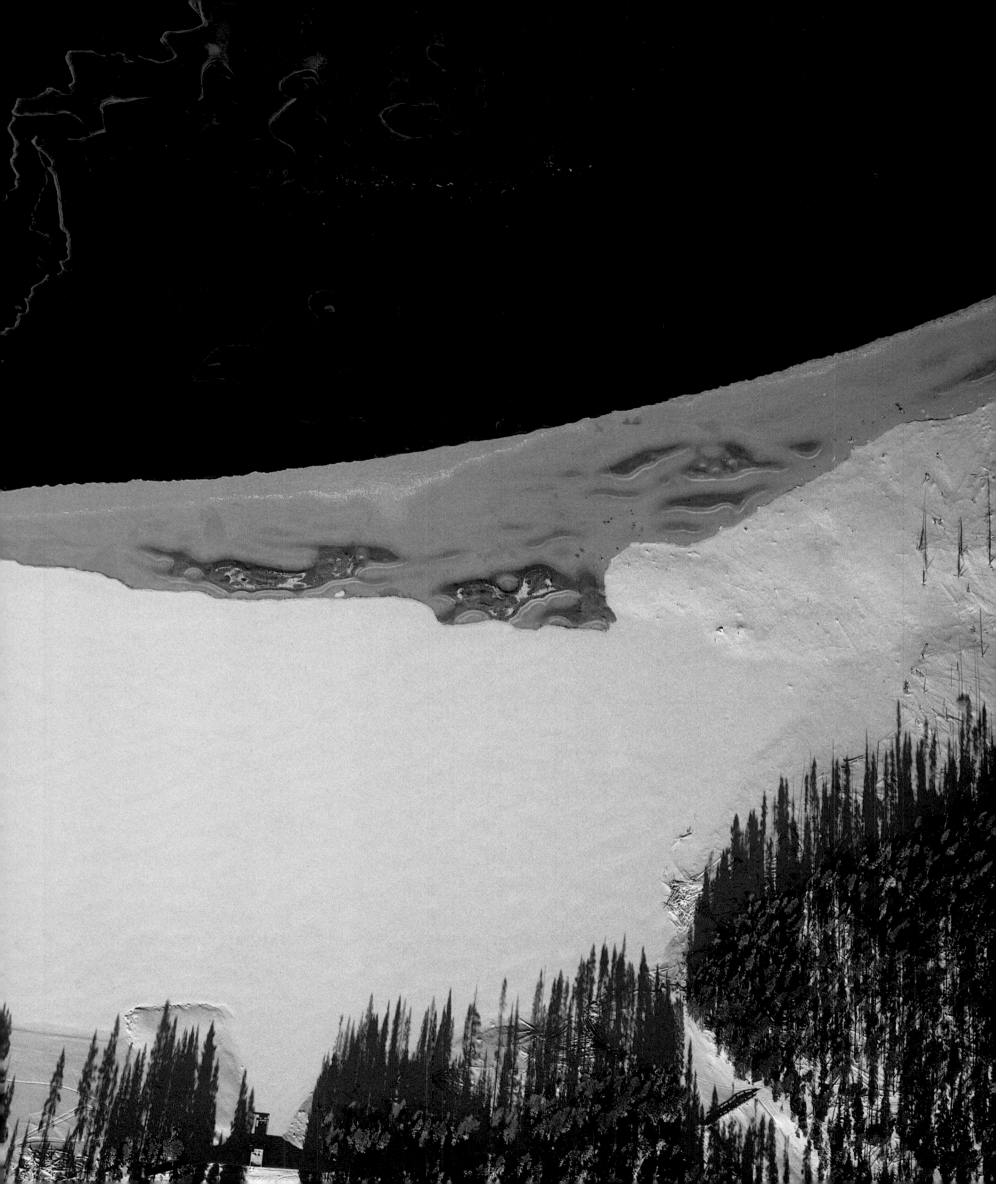

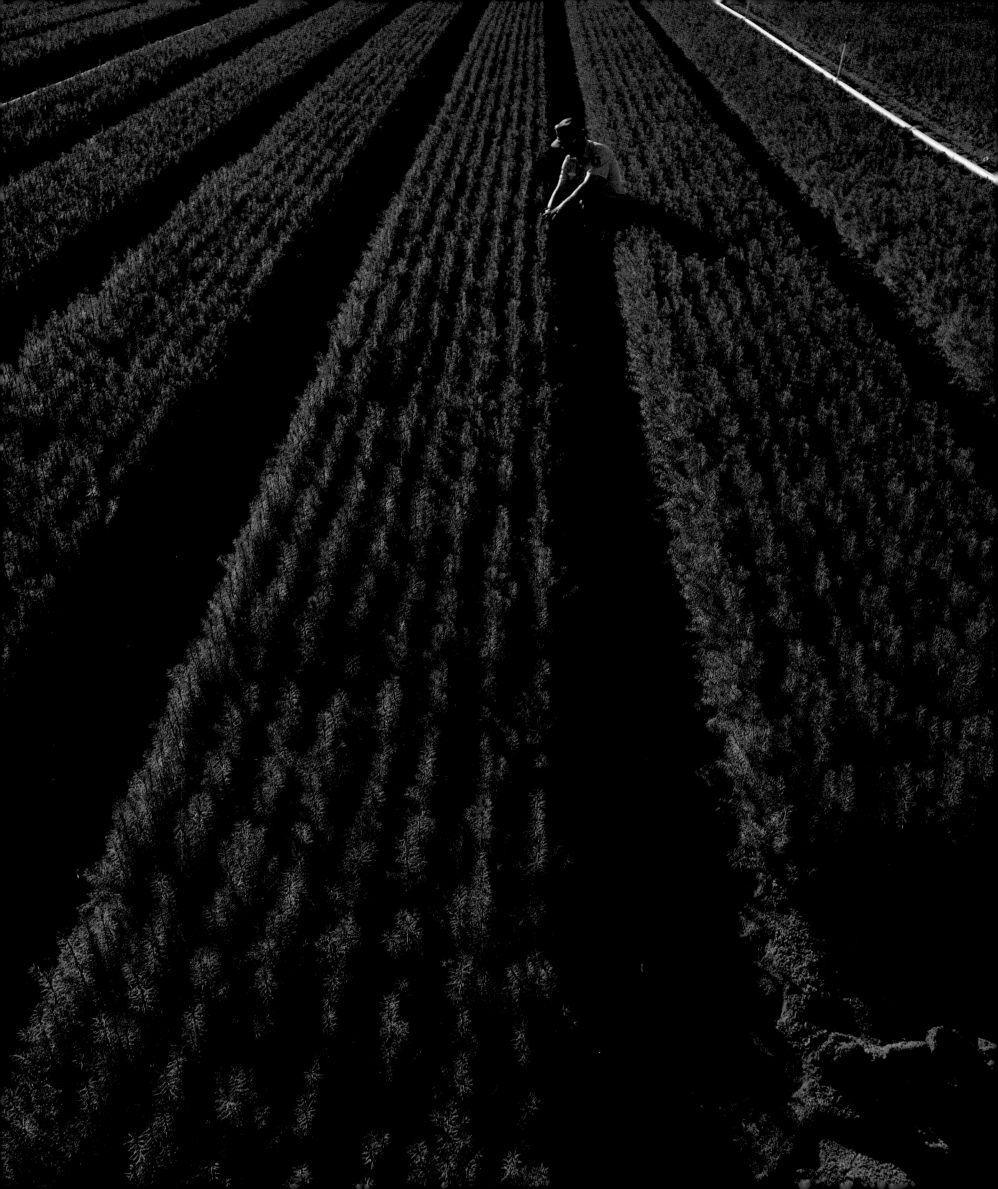

UMPQUA

UMPQUA · September sunrise. Fog rises to meet the sun. Ospreys leave their cries in the still blue sky brushed with a touch of cloud. The air is the essence of blackberries. The North Umpqua River runs cold, clear. You wade deep over rugged, slippery rocks; a long smooth cast lets your fly fall gently on a pool. A red and yellow body, with a red and white bucktail, waits, darts. Come, you moody, silver, steelhead beauty. Rise. Challenge me. Lure me. Let me feel your power. Wild fish, I promise to free you. A kingfisher swoops by; river otters chase each other. A vulture looks for the life parade to come to a screeching stop. Scarlet vine maples, purple dogwoods, red poison oak watch. You are on the most challenging, freshwater fly-fishing river in the world. Not a place for instant gratification. But maybe, peace.

■ Left: *Rogue River NF. Approximately seventy percent of seedlings grown in J. Herbert Stone Nursery are ponderosa pine and Douglas-fir. Capable of producing 24,560,000 seedlings yearly, the nursery ships to many of Oregon's forests—Rogue River, Umpqua, Winema, Ochoco, Deschutes, Willamette, Siskiyou, Fremont, Malheur—and the Shasta Trinity and Klamath in California.*

Lightning fractures Mount Thielsen's needle point, leaving a solid black onyx vein. You have free-climbed from Chicken Point; twenty-five hundred feet straight down is the rest of the world. Below, Diamond Lake is alive in summer for fishing, camping, biking. In winter, it is iced and snow-covered, a cross-country paradise, like skiing on the chest of the earth. And Mount Bailey, warm, round, the mother figure of the native Umpquas, their vision quest mounds face here. This mountain holds their Spirit inside. And this forest holds their medicine trees . . . trees with large rectangles cut out. Trees to cure. For more than eight thousand years, the Umpqua Indians lived here. Now only caves with pictographs and trees with scars remain. At Squaw Flats you can hear the wind singing as they gathered their acorns. White oak listens.

You follow a bull elk for hours, along stream beds, through dense fern and rhododendron, hemlock and white pine. The largest continuous stand of natural forest in the United States is here on the Umpqua. You are deep within its belly. Searching for an elk, a fish, a self. The *Umpqua*—a name Indians used to describe the land where the river lived. Challenge me. Lure. Let me feel your power.

ROGUE RIVER · Beginnings, where a mountain found a place to shed its tears slowly seeping out over soft spongy carpet. Mount Mazama lets a river go free. No one a master, no one a conqueror. We all rise, humbled, at the knees of Crater Lake. The Rogue River begins. You begin.

Follow this river back in time through steep gorges of gray-white pumice—the youngster, only seven thousand years old—past black-brown basalt drenched in moss; to yellow, red, green-spotted lava, dropped here before there ever was a Mount Mazama. Run, river, run, icy, clear, carving a path in old-growth lodgepole, mountain hemlock, over waterfalls and logjams, meandering by meadows. Then gone—sucked into lava tubes beneath the earth at Natural Bridge, then exploding back, blue-white, powerful. Like the Takelma Indians who the French-Canadian trappers called *Les Coquins,* "the Rogues," because they would not yield their land. Run, river, run.

This is a forest with a river for a heart and two mountain ranges to share it with, the Cascades and the Siskiyous. Different as night and day. The Cascades are thicker, denser, shrouded in ponderosas, giant sugar pines, and Douglas-firs, punctuated by Mount McLoughlin stuck into an azure sky. But Bigfoot tempts you to the Siskiyous, to Cougar Gap, to marble cliffs where you sense an ancient power lives. Isolated. Weeping spruce, Alaska yellow cedar, a goshawk and a winter wren. Wary.

June opens the alpine country, tucks winter skiing away on Mount Ashland, takes you hiking the Pacific Crest Trail. Spread out before you, a sea of mountains, as if you could stride ridge after ridge to the ocean. You have the odd sense that you are someone else's horizon. Bees beckon you to meadows of red columbine, pink penstemon hugs the crevices, ravens clutter the sun, springs spill down the slopes. Every turn is another view, another forest. Mount Shasta is out there, the rim of Crater Lake. The wind beats the shaggy-barked incense cedar, the jigsaw of the Jeffrey pine. Stunted sentinels on the slopes of Red Mountain. Unyielding.

You are in the Rogue. Ride a cloud. Watch a river.

ROGUE RIVER

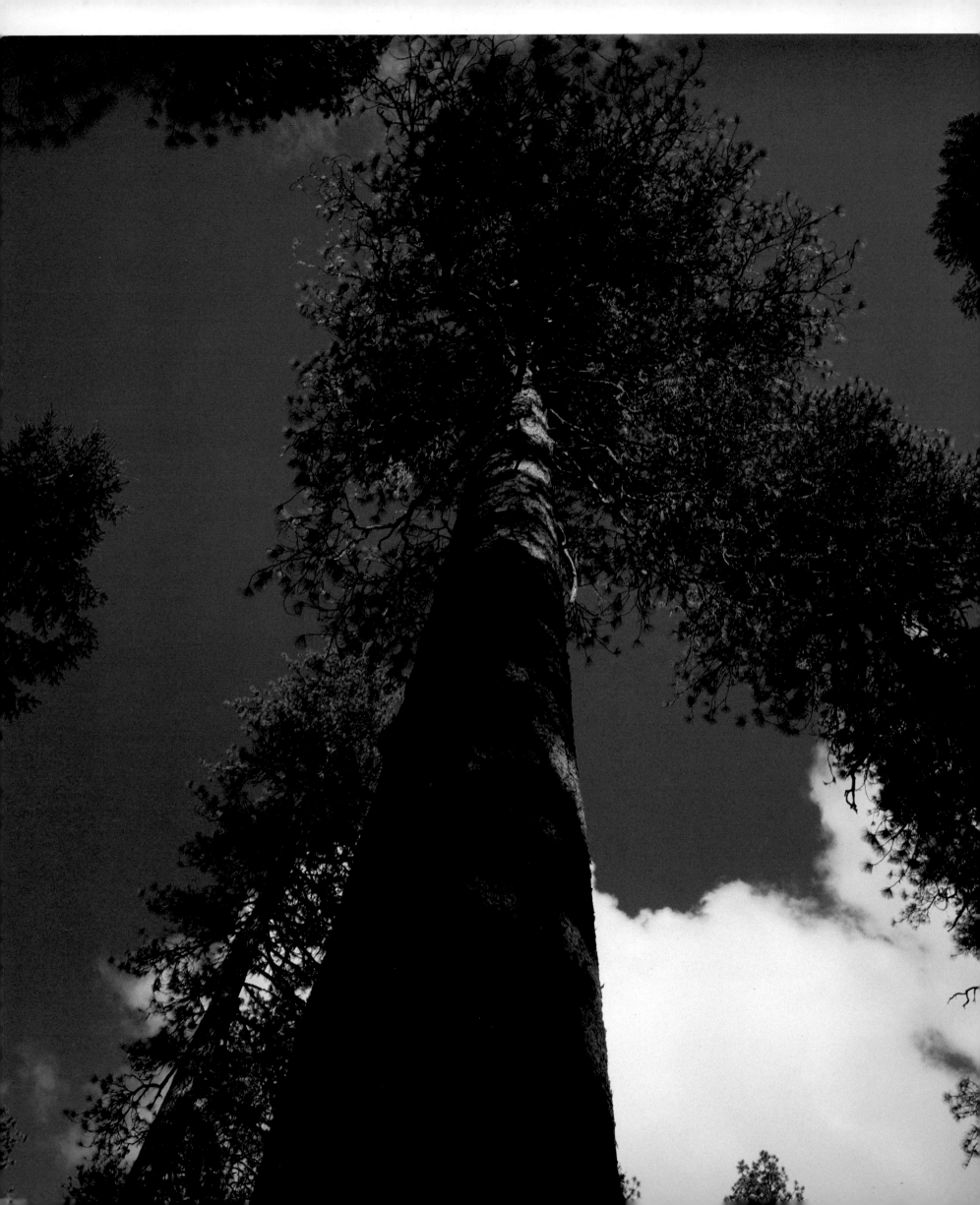

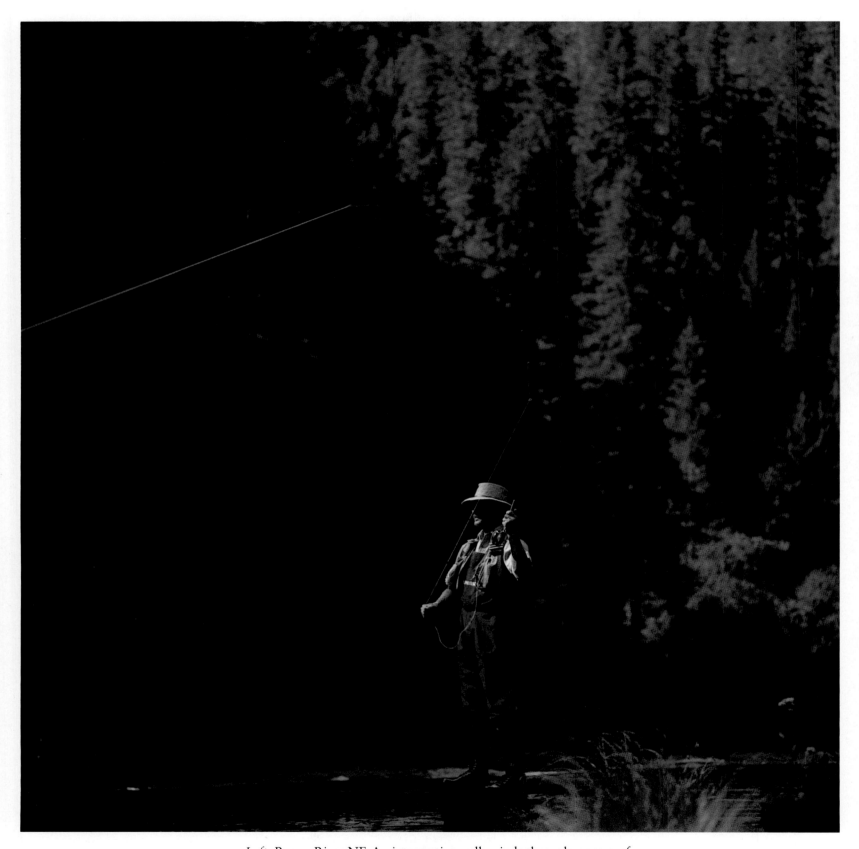

■ *Left:* Rogue River NF. An interpretive walk winds through a grove of old-growth sugar pine, the largest member of the pine family. Indians gathered its sweet seeds and ate the resin for which the pine was named.
■ *Above:* Umpqua NF. The Umpqua National Forest controls 784,834 acres and is world-renowned for steelhead trout. Specks of color along the river, fly-fishermen cast their lines, each fishing in a world apart. *Umpqua* was the Indian name both for the locality and the tribe which lived there.

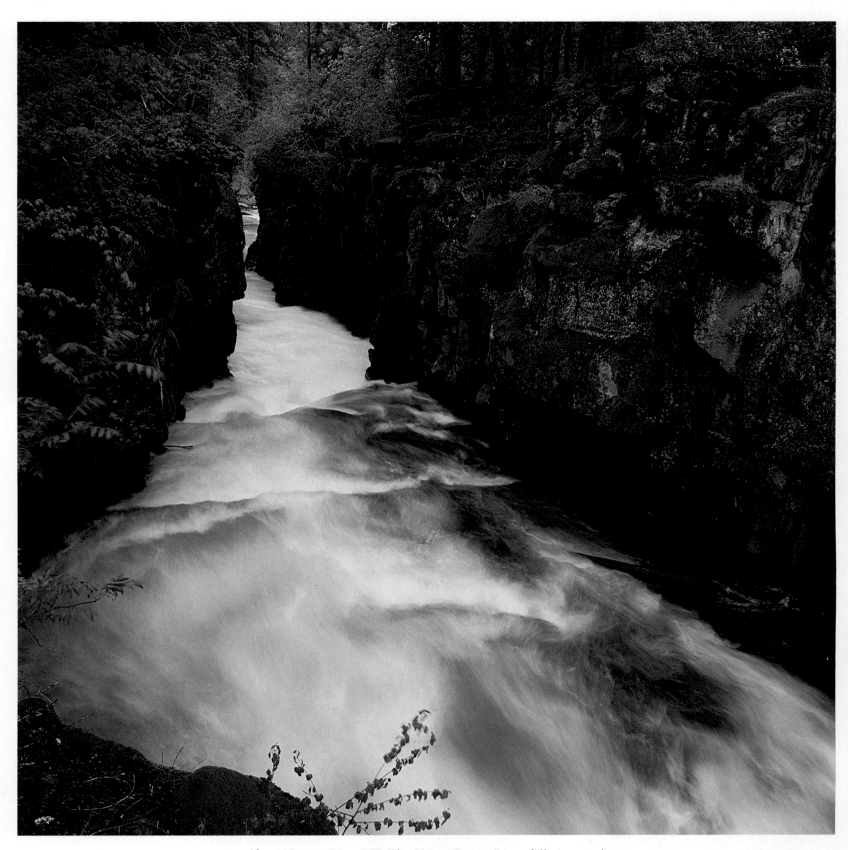

■ *Above:* Rogue River NF. The Upper Rogue River falls into a chasm near Union Creek. The waters rush between walls of volcanic rock, and a fine mist rises out of the gorge. ■ *Right:* Umpqua NF. Mount Thielsen rises above an iced-over Diamond Lake. Situated high in the Cascades, the lake is shallow, quickly freezing in winter. Ice skating, cross-country skiing, and snowmobiling are popular winter activities. During the summer, fishing and a variety of water sports are favorites.

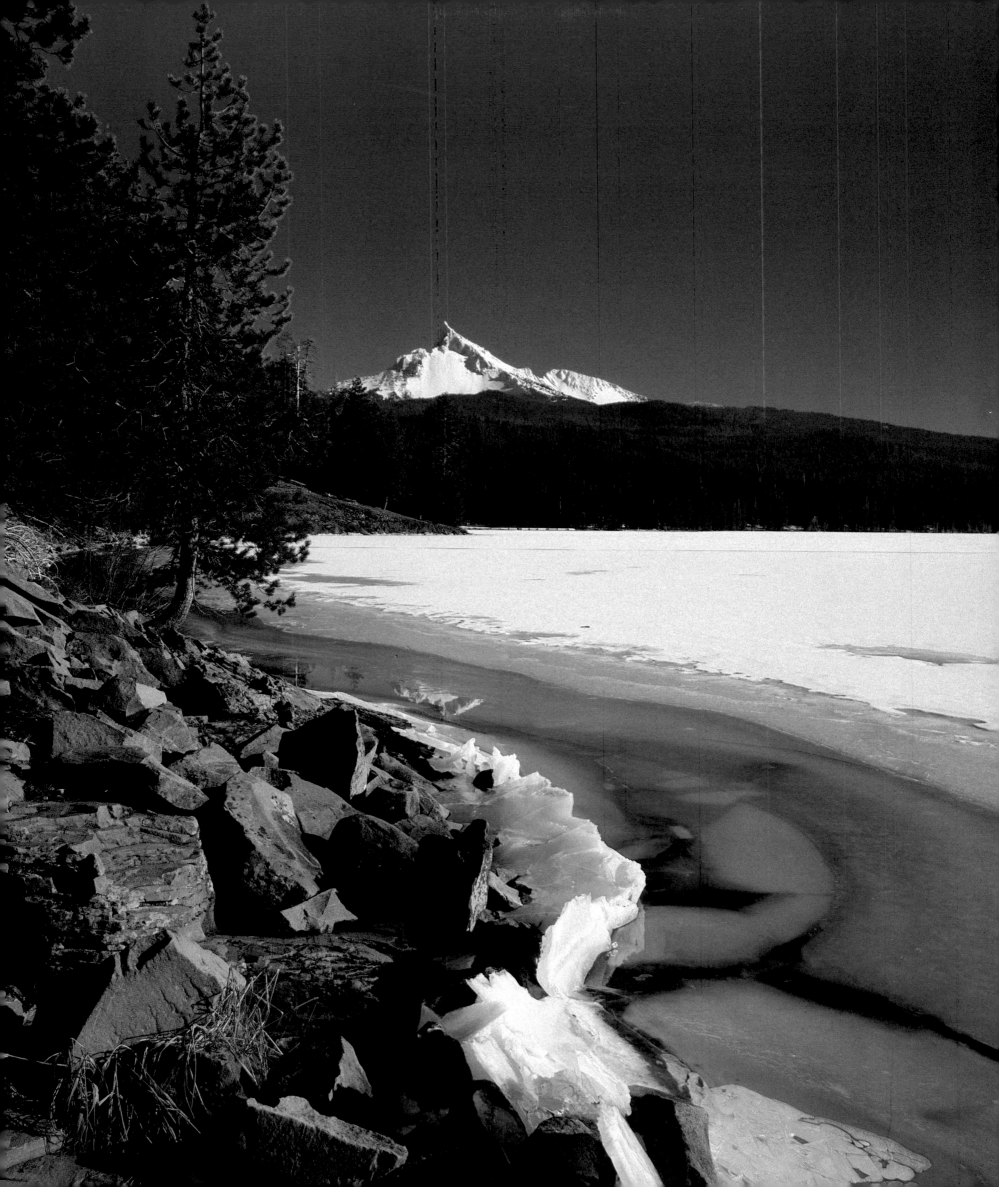

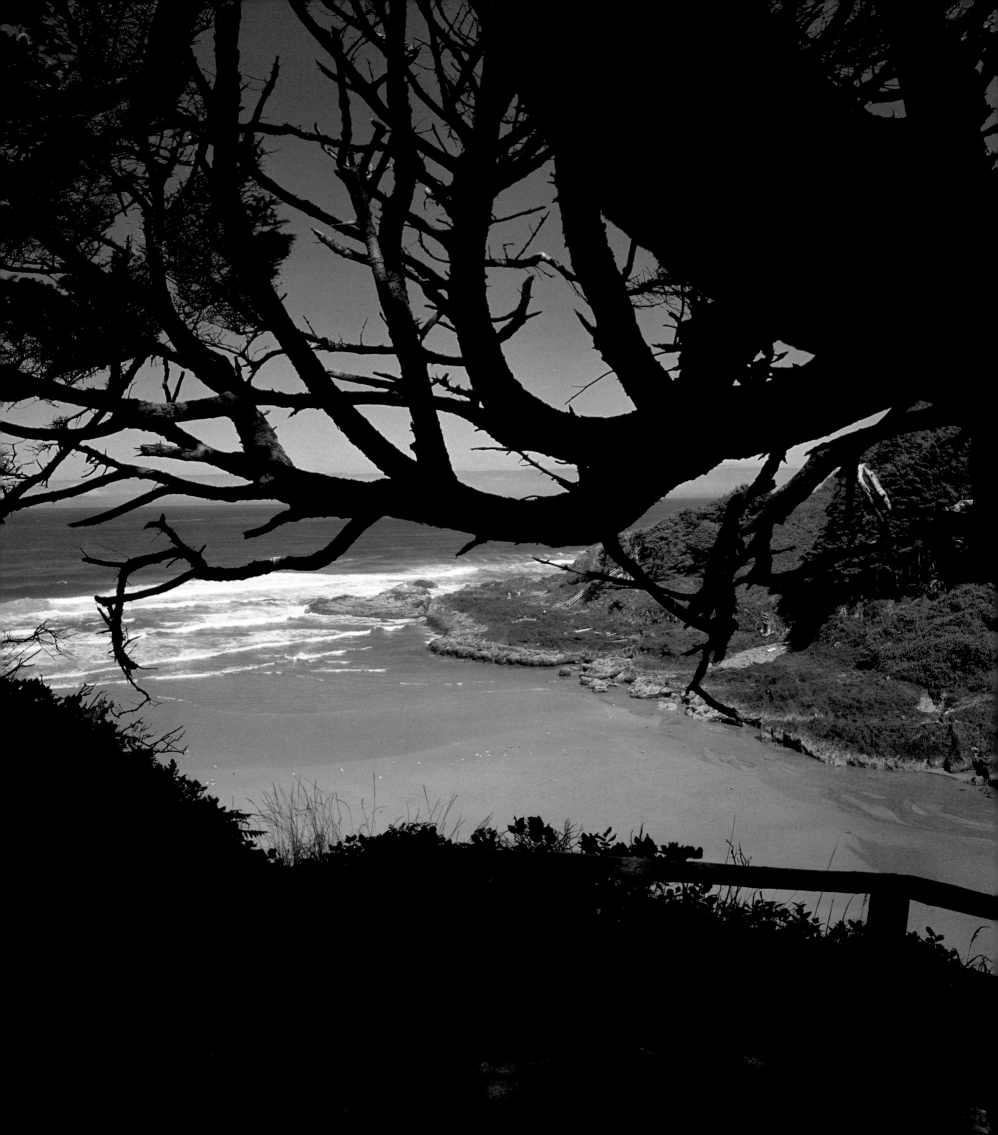

SISKIYOU

SISKIYOU · Noah obeyed God's command and saved all flesh . . . "birds and animals and every creeping thing." (Genesis 8:17) The Siskiyous became their own Noah's Ark—a refuge for growing things. The Ice age left an island open, nature's seed bank, a bounty of botanical diversity. The Siskiyous. But it left its mysteries, too. When other mountains go north-south, why do these go east-west? When other mountains have wet and dry sides, why are the Siskiyous a mix of tropical air bringing redwoods, and arctic air bringing Alaska yellow cedar? When other mountains have a logical composition, the Siskiyous are a geologic jumble like children's blocks strewn higgledy-piggledy, pop. Josephine Sheet is a gigantic wet desert of red peridotite rock, a bonsai moonscape of dwarfed Jeffrey pine and incense cedar, but alive in the spring with

■ Left: *Siuslaw NF. Cape Perpetua has many faces—the delicate complexity of a tidepool, the violence of crashing waves in the Devil's Churn, the muffled quiet in a stand of old-growth Sitka spruce, the spouting of migrating whales.* ■ Overleaf: *Siuslaw NF. Cascade Head was set aside as an experimental forest in 1974. It covers nine thousand acres.*

wildflowers and birds. Smack dab in the middle is a massive old-growth forest of Douglas-fir, Port Orford cedar, sugar pine, and tanoak. There is a saying here: If you don't like what you see, walk a hundred yards.

What is this place? It is fiercely beautiful: remote and wild, impenetrable and steep, diverse and rare. It is the Illinois River, the most unforgiving, multi-day kayak and raft trip in the West. Completely isolated, the raging, clear green waters slam you down narrow granite walls, through forested canyons pummeled by waterfalls. No way out but this river. Now run it all in spring, rain, and cold. Or try the Rogue River, challenging, but with time to drift; watch otters and ospreys; fish for salmon, steelhead, and trout.

Dense, craggy terrain. A pile of peaks. Kalmiopsis Wilderness. Thick with trees that don't belong together: Douglas-fir, Brewer's spruce, madrone, grand fir. Haven for rare plants: the *Kalmiopsis,* a knee-high relation to rhododendron. Home to pygmy, spotted,

and screech owls; burning heat in summer; drenching rains in winter; black bear and solitude. Such solitude.

Or stand deep in sword fern; look up at Oregon's ancient redwoods. God in fog. The *Siskiyous,* Cree for a bobtailed horse, lost in a snowstorm in the mountains that bear his name. Suspend all rules. Expect a mystery. You will not be disappointed.

SIUSLAW · You are in a dense, damp, deep-green forest with a sapphire-blue and snow-white ocean for a front door. Anything that stands still long enough will grow: even sand dunes sprout forests. Kneel down and see hermit crabs scamper to a new home, orange starfish creep carefully, green spitting anemones hold fast, mussels wait patiently for the sea to return. Not a half-mile away, giants hold sway, old-growth Sitka spruce, western hemlock, Douglas-firs. Rivers, undammed, flash with wild fish: silver salmon, steelhead, cutthroat trout. Water drips everywhere, from the sky, plants, the glistening sides of steep, rugged slopes. There are fog-shrouded mornings, fresh winds, sun and stillness, and the power of a winter storm. The *Siuslaw,* an Indian name for a tribe, a chief, a place. There is no other place like it in Oregon.

Life is absolutely abundant here. Bushwacking, you can walk from the headwaters of Cummins Creek to the ocean, through deep, thick underbrush of sword fern, salal, and salmonberry; under huge Sitka spruce and alder; over carpets of white oxalis. Autumn-red vine maple hugs the banks. Do not look out here, look through, down, in. Giant Pacific salamanders scurry. Secretive seabirds, marbled murrelets fly back into old-growth Douglas-fir and lay their eggs on a branch in a palm of moss. At Rock Creek, the threatened Oregon silverspot butterfly holds out. Life on intimate terms.

On Marys Peak, topped with grasses and lilies, you can see from Mount Rainier to Diamond Peak. A rock garden lies strewn with Douglas pink, orange wallflower, patches of spreading phlox. Walk through meadows of wild blue iris, tiny purple violets; stand under a grove of old-growth noble fir.

Run wild down a sand dune, hang glide from a ridge, canoe on a stream, ride buggies over shifting sands, birdwatch on an estuary. Oregon's Dunes, the largest in the West—fourteen thousand acres of sand, forest, freshwater lakes, and creeks; of shorebirds, ducks, and dunes to last you a lifetime.

The Siuslaw. The ebb and flow of life beats here.

SIUSLAW

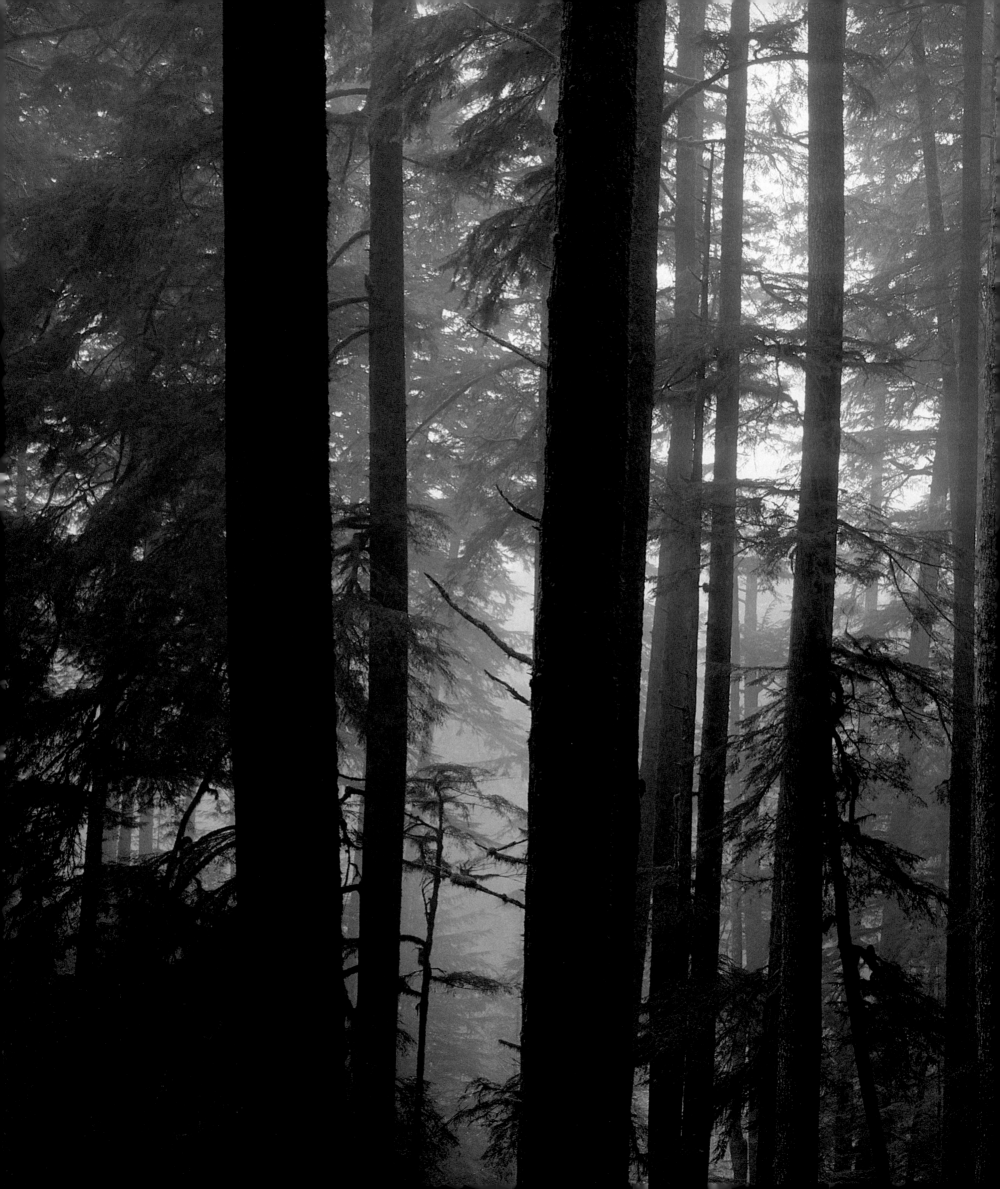

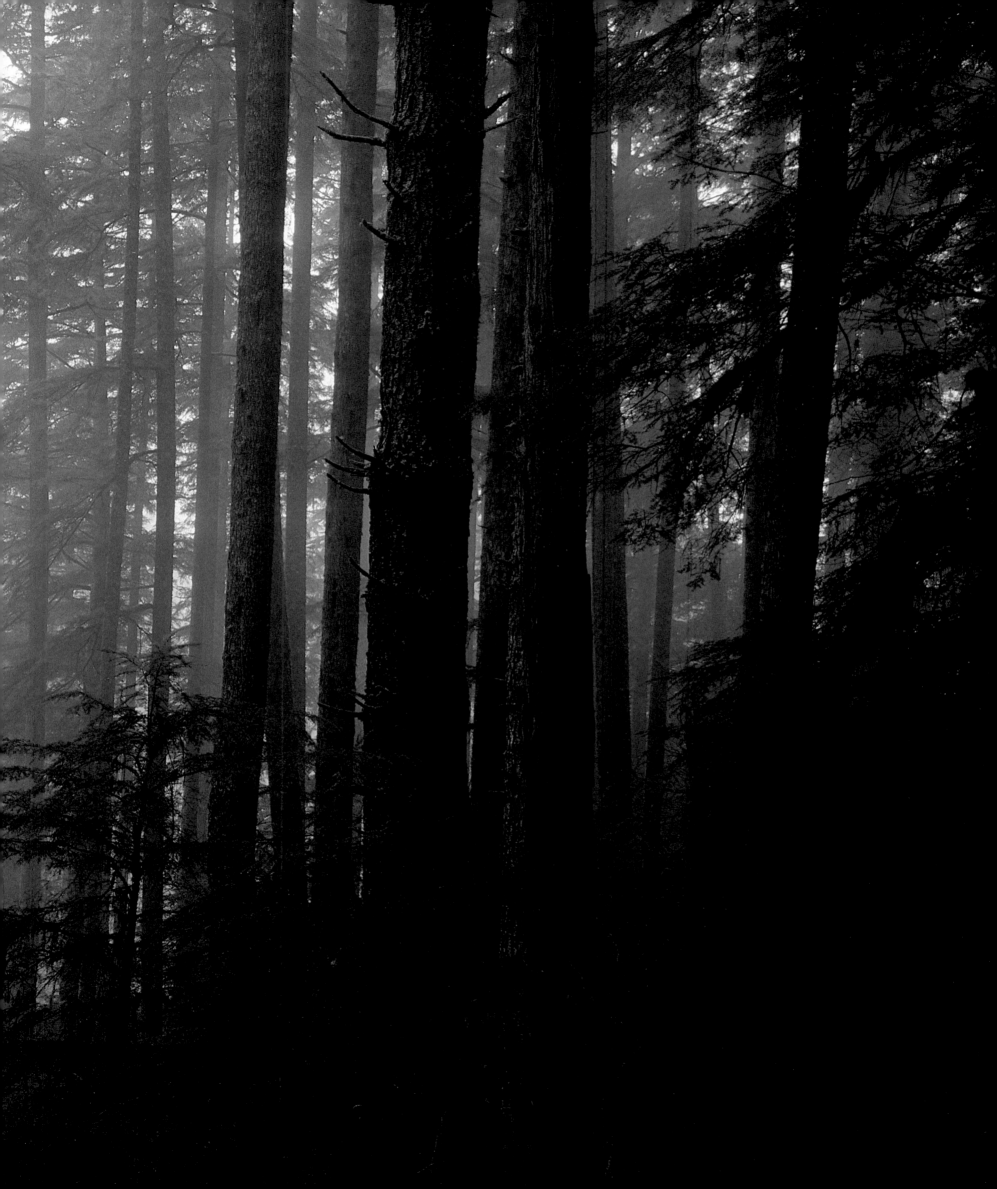

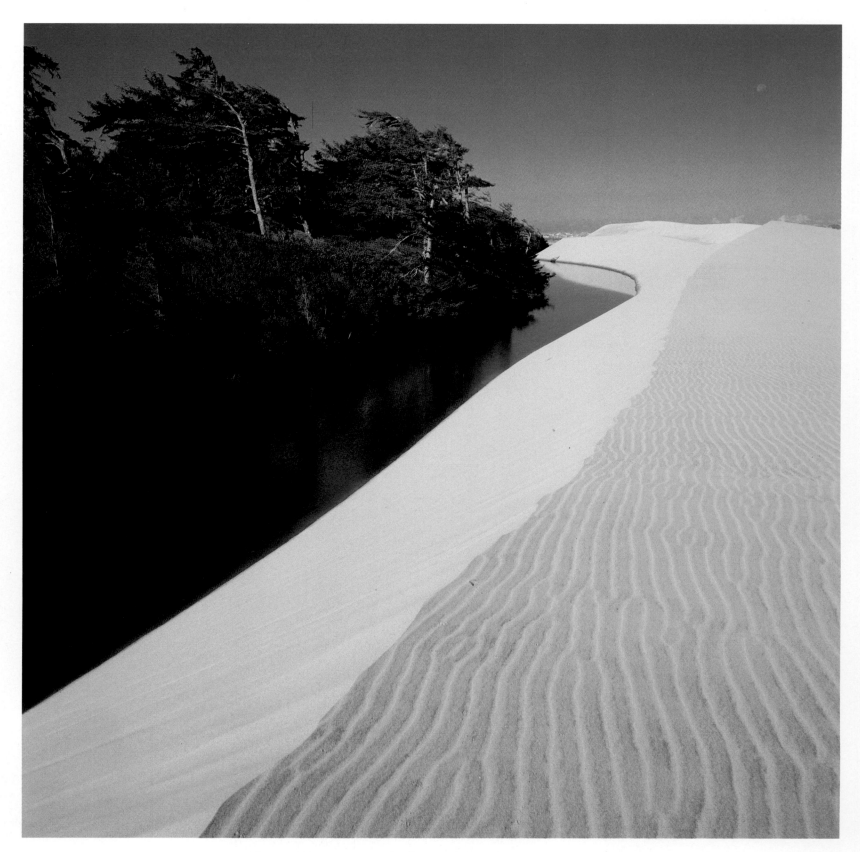

■ *Above:* Siuslaw NF. Coastal pines stand along the trail by Sutton Creek. The powerful ocean waves and the on-shore winds have eroded old rocks into tiny particles and have carried sand from beaches and rivers. The material is deposited on the shoreline where winds blow it into the sand dunes which occur along the coast from Florence to Coos Bay.

There are fog-shrouded mornings, fresh winds, sun and stillness, and the power of a winter storm.

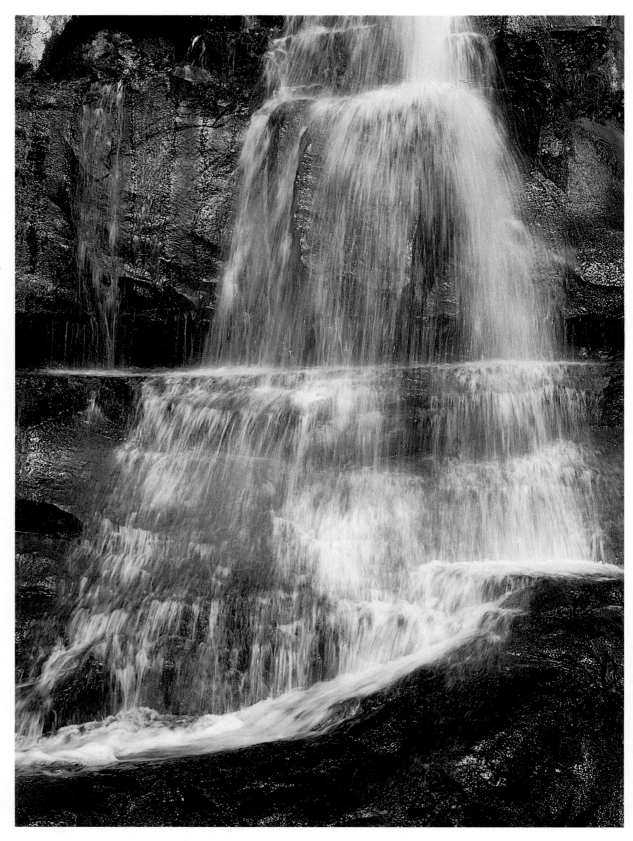

■ *Above:* Siskiyou NF. A path descends sharply through the old-growth forest down to Coquille Falls. Although cool and beautiful on this warm summer's day, the falls can be spectacular in their turbulence during spring run-off. Adding brilliant color to the forest's peaceful green, azalea and rhododendron grow interspersed on the forest floor.

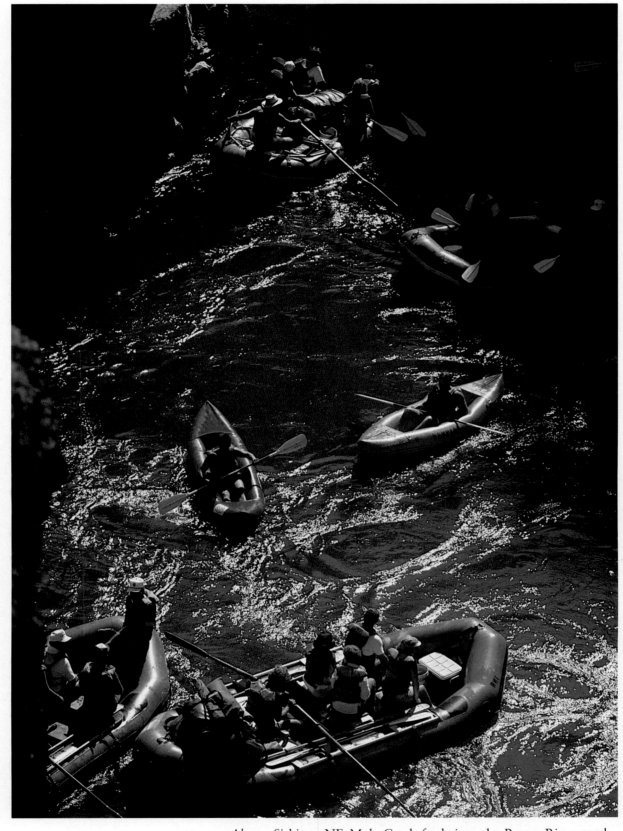

*It is fiercely
beautiful: remote
and wild,
impenetrable and
steep, diverse
and rare.*

■ *Above:* Siskiyou NF. Mule Creek feeds into the Rogue River north-east of Mule Creek Canyon. Rafters float between boulders which are dubbed "The Jaws," into "The Narrows," and through "The Coffee Pot," to arrive at Stair Creek Falls, where the river calms. ■ *Right:* Siskiyou NF. Home to more than fourteen hundred species of plant life, the Kalmiopsis Wilderness supports a number of rare botanical species. ■ *Overleaf:* Siuslaw NF. The Devil's Churn lives up to its name.

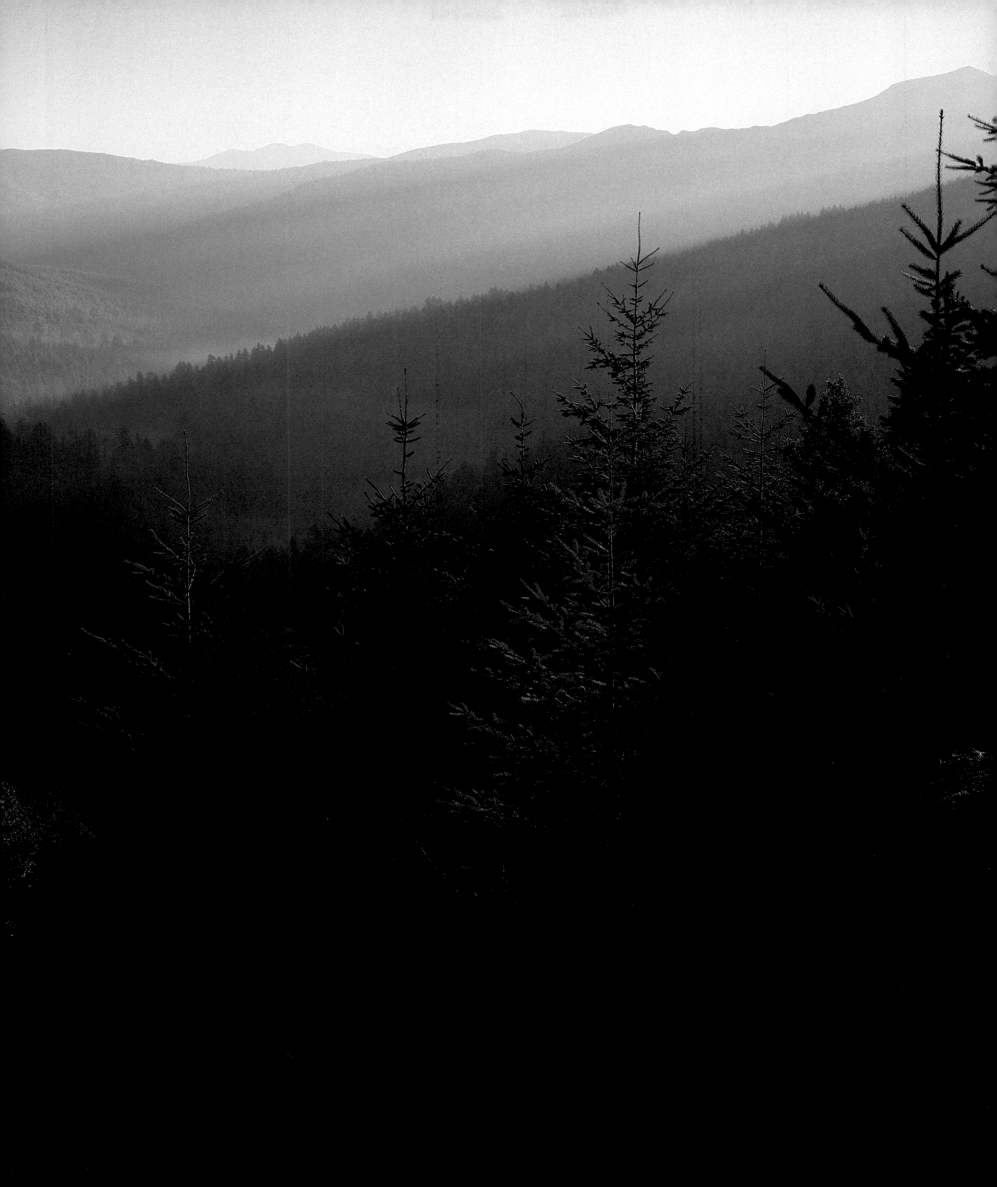

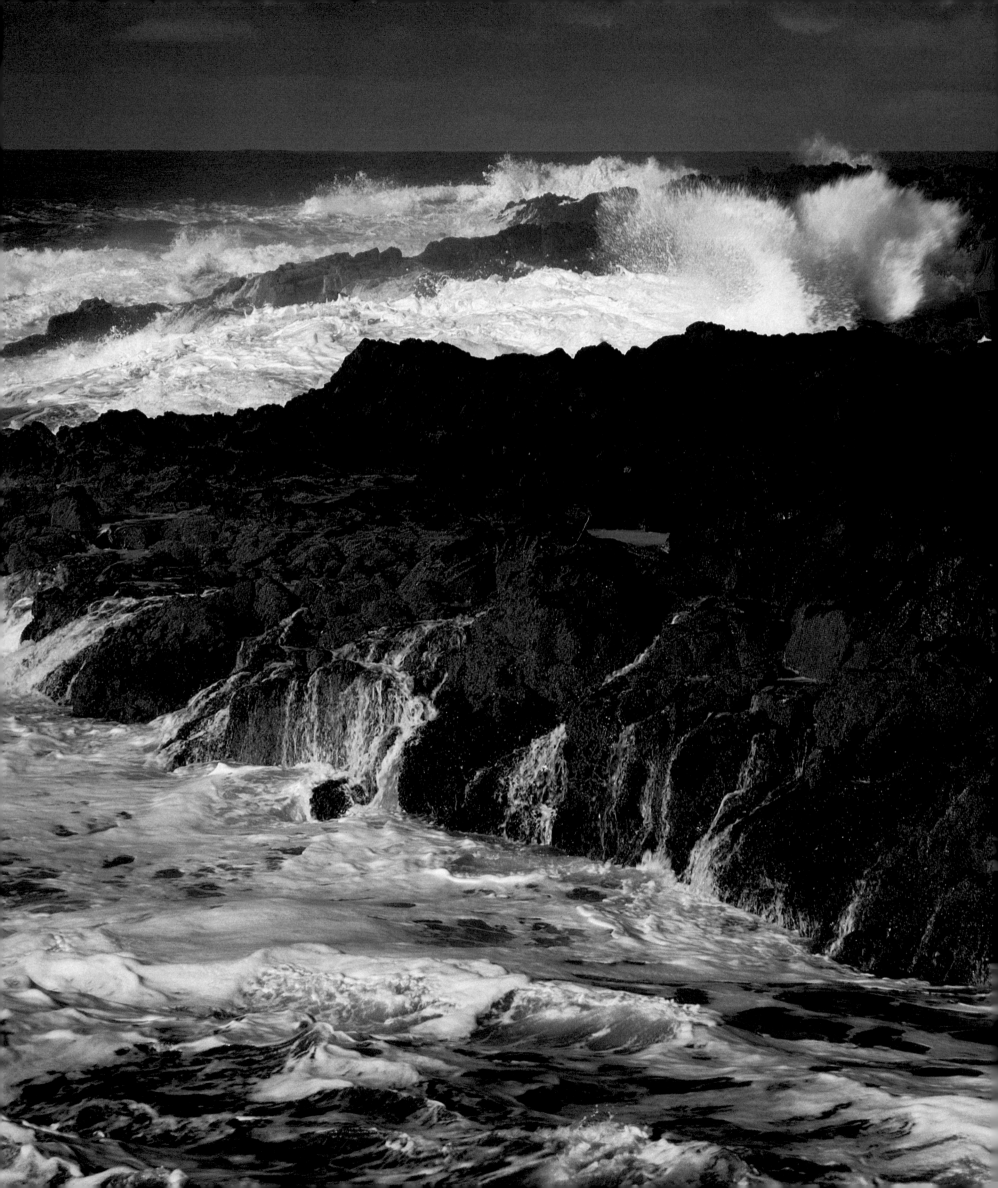

OREGON'S
NATIONAL
FORESTS

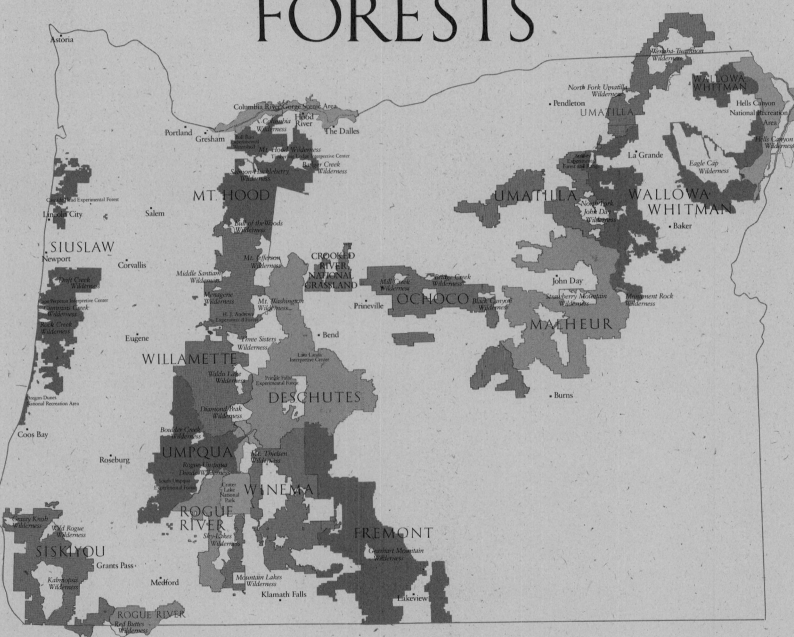

MT. HOOD

Area • 1,061,381 acres

National Scenic Area • Columbia River Gorge National Scenic Area, 31,143 acres in Mount Hood NF of total 277,000 acres

Wilderness Areas • Badger Creek, 24,000 acres • Bull of the Woods, 26,360 acres of total 34,884 acres • Columbia, 39,000 acres • Mount Hood, 46,520 acres • Mount Jefferson, 4,743 acres of total 106,958 acres • Salmon-Huckleberry, 44,550 acres.

Experimental Watershed • Bull Run, 945 acres

Major Visitor Interpretive Centers • Multnomah Falls • Timberline Lodge

Ranger Districts • Barlow • Bear Springs • Zigzag • Estacada • Clackamas • Columbia Gorge • Hood River

Location • Northern Oregon Cascade Range.

Geography • Rain forests on Cascade Range's west side, tundra on high mountain slopes. Dry pine and oak lands on east side, near high desert.

History • On October 29, 1782, Lieutenant William E. Broughton was the first explorer to see Mount Hood while exploring Columbia River on orders from Captain George Vancouver.

Flora and Fauna • Animals: Elk, bear, deer • Birds: Wood ducks, ring-necked ducks • Trees: Douglas-fir, ponderosa pine, lodgepole pine • Wildflowers: Orchid, avalanche lily, bleeding heart, coltsfoot, bead lily, woodland violet, Johnny-jump-ups, white trillium, purple calypso orchid, blue delphinium, Indian paintbrush

Recreation Opportunities • Fishing • Biking • Windsurfing • Whitewater rafting • Hiking • Mountain and rock climbing • Downhill and cross-country skiing • Camping

Points of Interest • Mount Hood • Barlow Road • Timberline Lodge • Columbia River • Columbia River Scenic Highway • Vista House on Crown Point • Multnomah Falls • Governor Tom McCall Preserve

Supervisors

Columbia River Gorge National Scenic Area
Waucoma Center, Suite 200
902 Wasco Avenue
Hood River, Oregon 97031
503/286-2333

Mount Hood National Forest
2955 NW Division
Gresham, Oregon 97030
503/666-0700

Cross country skiers and a snowmobiler meet on Trillium Lake Basin snow trails in 1969.

Deer near Cascadia in the Willamette. 1934.

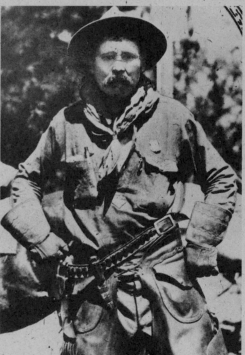

Fritz Sethe was a Forest Service ranger from 1910-1915.

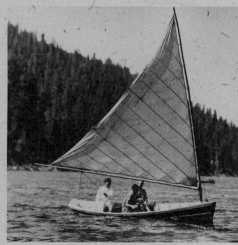

Sail boating has been a tradition on Wallowa Lake for as far back as 1937.

DESCHUTES

Area • 1,605,055 acres

Wilderness Areas • Diamond Peak, 32,567 acres of 52,329 total acres • Mount Jefferson, 32,734 acres of 106,958 total acres • Mount Thielsen, 6,800 acres of 55,100 total acres • Mount Washington, 13,886 acres of 52,559 total acres • Three Sisters, 93,469 acres of 285,001 total acres

Experimental Forest • Pringle Falls, 11,055 acres

Major Visitor Interpretive Center • Lava Lands

Ranger Districts • Bend • Crescent • Sisters • Fort Rock

Location • Southern Oregon's Cascades

Geography • Flower-studded alpine meadows and icy Cascade Mountain peaks are in the heights. Its eastern edge is fringed by lands with low shrubs and hardy native bunchgrasses. Both volcanic upheavals and glaciers sculptured the national forest, which parallels the Oregon Cascades on the eastern side.

Flora and Fauna • Animals: Mule and black-tailed deer, Roosevelt elk, black bear, pronghorn antelope • Birds: Osprey, Clark's nutcracker, white-headed woodpecker, calliope hummingbird, bushtits, pine siskin • Fish: Rainbow, Mackinaw, brown, and brook trout; Atlantic and Kokanee salmon; mountain whitefish • Trees: Ponderosa, whitebark, and lodgepole pine; mountain hemlock

Recreation • Hunting • Fishing • Skiing • Hiking • Spelunking

Points of Interest • Lava Lands Visitor Center, 11 miles south of Bend on U.S. Highway 97 • Mile-long Lava River Cave, one of the longest volcanic tubes in the Northwest • 25-mile wide caldera of Newberry Crater • High Desert Museum, six miles from Bend • Oregon's second-highest peak, 10,497-foot Mount Jefferson • Redmond Fire and Aviation Center, the heart of the region's fire fighting network

Supervisor
Deschutes National Forest
1645 Highway 20 East
Bend, Oregon 97701
503/388-2715

An expert skier took off from a snow cornice at Hoodoo Ski Bowl in 1964.

WILLAMETTE

Area • 1,676,879 acres

Wilderness Areas • Bull of the Woods, 8,526 acres of total 34,884 acres • Diamond Peak, 19,762 acres of total 52,329 acres • Menagerie, 4,715 acres • Middle Santiam, 8,542 acres • Mount Jefferson, 69,481 acres of total 106,958 acres • Mount Washington, 38,673 acres of total 52,559 acres • Three Sisters, 191,532 acres of total 285,001 acres • Waldo Lake, 37,138 acres

Experimental Forest
• H. J. Andrews, 15,800 acres

Ranger Districts • McKenzie • Blue River • Oakridge • Detroit • Rigdon • Lowell • Sweet Home

Location • The size of New Jersey, Willamette National Forest stretches for 110 miles along the western slope of the Cascade Mountains.

Geography • Volcanic cones and lava flows are buried under verdant forest, but still show effects of glacial scouring and erosion, remnants of the Ice age which followed the era of volcanic activity.

Flora and Fauna • Animals: Roosevelt elk, bear, mink, black-tailed and mule deer • Fish: Brook, rainbow, brown, cutthroat, and bull trout; Kokanee salmon • Trees: Douglas-fir, cedar, grand fir, hemlock

Recreation • Downhill and cross-country skiing • Snowmobiling • Hiking • Fishing • Camping • Picnicking • Hunting

Points of Interest • Waldo Lake, one of the purest bodies of water in the world and Oregon's second-largest lake • Eight wilderness areas encompassing seven major Cascade Mountain peaks • 100 miles of Pacific Crest National Scenic Trail • Total of 1300 miles of trail • Trails at McKenzie, Fall Creek, and South Breitenbush • Snowmobile trails on Waldo Lake Road and at Big Lake • Skiing available at Hoodoo and Willamette Pass

Supervisor
Willamette National Forest
211 East 7th Avenue
P.O. Box 10607
Eugene, Oregon 97440
503/465-6521

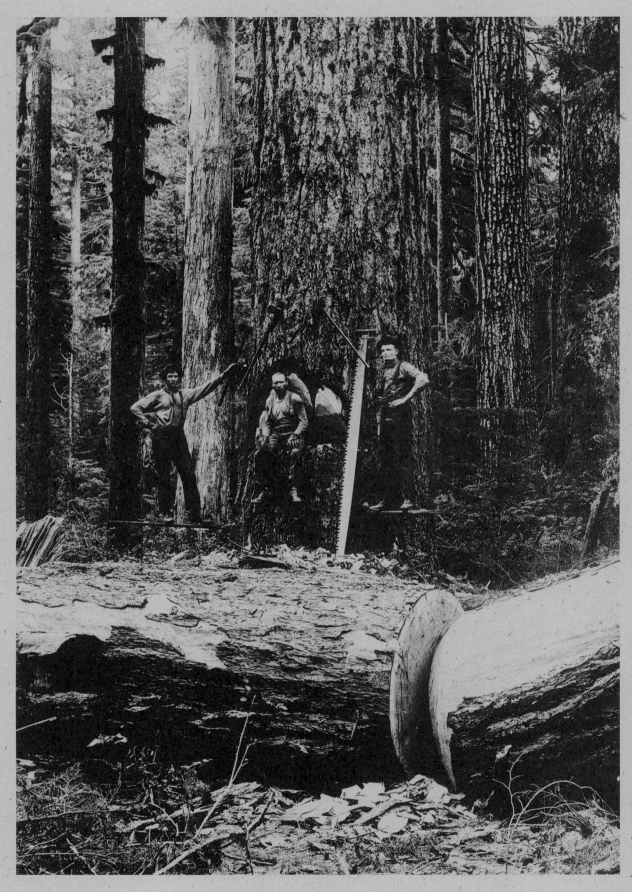

Lumbering "Douglas spruce."
Falling, bucking, or sawing
apart and "sniping" on
rounding edge of log to
facilitate taking out. 1899.

MALHEUR

Area · 1,461,805 acres

Wilderness Areas · Monument Rock, 12,700 acres of a total 19,780 acres · Strawberry Mountain, 68,299 acres

Ranger Districts · Bear Valley · Burns · Long Creek · Prairie City

Location · Blue Mountains in Grant, Harney, Baker, and Malheur counties

Geography · Juniper and sage flats change to rolling foothills of trees. These give way to mountain meadows full of wildflowers, subalpine trees and shrubs, and lakes. The lowest elevation on the forest is about four thousand feet. The highest is the top of Strawberry Mountain, over nine thousand feet. Rolling foothills and valleys rise to massive rock outcrops and cliffs.

History · The Malheur River was so named by a French trapper because Natives stole supplies near the river. The forest has long been known as "gold and cattle country."

Flora and Fauna · Animals: Rocky Mountain elk, bear, bobcat, bighorn sheep, antelope, mule deer, chipmunk · Birds: Red-tailed hawk, red crossbill, pileated woodpecker, blue grouse · Fish: rainbow, cutthroat, redband; spring chinook, summer steelhead, mountain whitefish · Trees and other flora: Larch, willow, aspen, sumac, Alaska cedar, Douglas-fir, ponderosa and lodgepole pine, Englemann spruce; wild strawberries, silver sage; squirreltail, bluebunch grasses; yellow buckwheat, white angelicas

Recreation · Camping · Hiking · Backpacking · Horseback riding · Picnicking · Fishing · Bird watching · Wildlife viewing · Snowmobiling · Cross-country skiing

Points of Interest · Magone Lake with day-use and overnight camping · Arch Rock National Recreation Trail · Logan Valley's outstanding wildlife · Moderately difficult eight-mile hike on Malheur River National Recreation Trail · Easy-to-moderate one-mile hike in Cedar Grove Botanical Area · Drive through John Day Fossil Beds National Monument

Supervisor

Malheur National Forest
139 NE Dayton Street
John Day, Oregon 97845
503/575-1731

OCHOCO

Area · 845,498 acres

Wilderness Areas · Black Canyon, 13,371 acres · Bridge Creek, 5,380 acres · Mill Creek, 17,400 acres

Ranger Districts · Big Summit · Paulina · Prineville · Snow Mountain · Crooked River National Grassland

Location · High Desert country of central Oregon

Geography · A land of tremendous variety—rolling hills, picturesque canyons, unique geologic landforms, rivers, forest, and grasslands

Flora and Fauna · Animals: Beavers, kestrels, coyotes, wild horses, antelope, the largest mule deer population east of the Cascade Mountains, trophy-sized elk, livestock · Birds: Swallows, redwing blackbirds, horned larks; bald eagles, especially in Paulina Valley · Trees and plantlife: Ponderosa pine, cottonwood, aspen, willow, mock orange, alder, red osier dogwood, juniper; big sage, bunch grass · Wildflowers: shooting stars, bluebells, lupine · Fish: Rainbow and brook trout

Recreation · Rockhounding—for agate, thunder eggs, jasper · Hunting · Camping · Hiking · Snowmobiling · Cross-country skiing · Fishing · Bird watching—especially bald eagles in Paulina Valley · Photographing

Points of Interest · Paulina Valley's Bald eagles · 96 miles of trail · Twin Pillars · Steins Pillar · Lookout Mountain's wild horses · Mayflower Mining Settlement · Mount Pisgah · North Point · Viewpoint at 6,100 feet of John Day and Mitchell valleys · Round and Lookout mountains · Crooked River National Grasslands

Supervisor

Ochoco National Forest
155 North Court
P.O. Box 490
Prineville, Oregon 97754
503/447-6247

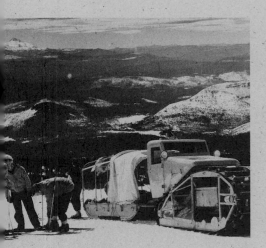

Snow motor rescue unit climbing the upper slopes of Mount Hood. 1944.

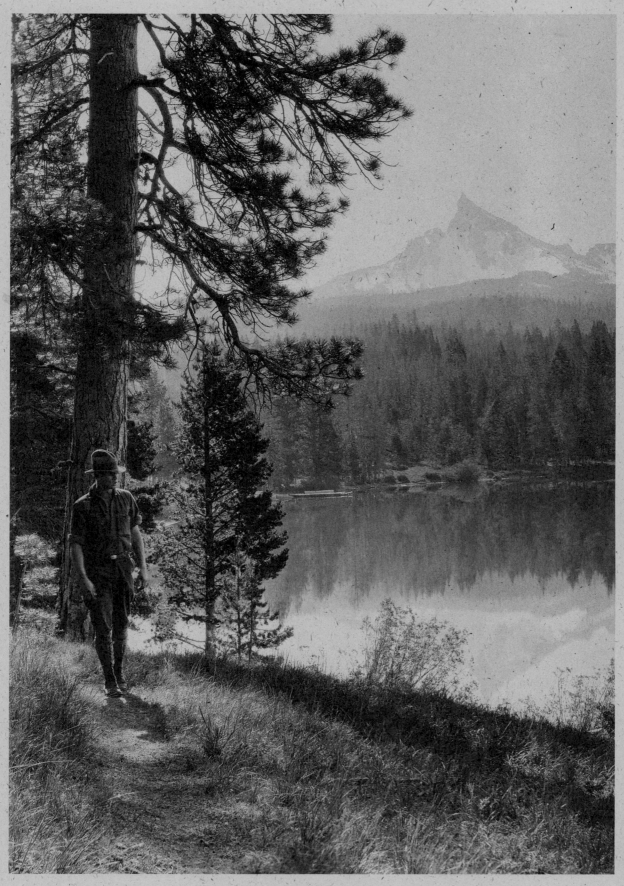

*Mount Thielsen in the
background, a ranger
checked the hiking trails
along Diamond Lake. 1923.*

UMATILLA

Area • 1,402,482 acres

Wilderness Areas • North Fork John Day, 106,726 acres of total 120,825 acres • North Fork Umatilla, 20,150 acres • Wenaha-Tucannon, 177,423 acres

Ranger Districts • Heppner • Walla Walla • North Fork John Day • Pomeroy

Location • More than a million acres of northeast Oregon and southwest Washington.

Geography • Elevations range from eighteen hundred feet to eight thousand feet. Landscape is mostly tablelands scoured by creeks and rivers into deep canyons, and also includes heavily timbered slopes of Blue Mountains, grassland ridges and benches, and granite outcroppings in Greenhorn Mountains.

Flora and Fauna • Animals: Bighorn sheep, whistling marmot, Rocky Mountain elk, black bear, deer • Birds: Ruffed grouse, blue grouse, chukar, pileated woodpecker • Fish: Chinook salmon, steelhead, rainbow trout • Trees: Douglas-fir, grand fir, western white pine, ponderosa pine, juniper, western larch, black cottonwood, yew • Wildflowers and plants: wild ginger, phantom orchids, Douglas onion, camas, balsam root, monardella, lupine; licorice, maidenhair fern

Recreation • 700 miles of trails • 3,800 miles of roads • 25 campgrounds • Hiking • Horseback riding • Hunting • Fishing

Points of Interest • Wenaha-Tucannon • North Fork Umatilla • North Fork John Day Wilderness • Fremont Powerhouse, nominated to the National Register of Historic Places • Olive Lake, formed by a glacier-created dam • Pendleton Roundup

Supervisor
Umatilla National Forest
2517 SW Hailey Avenue
Pendleton, Oregon 97801
503/276-3811

Cattle grazing near Dead Horse Lake, high in the Fremont NF.

WALLOWA-WHITMAN

Area • 2,256,686 acres

National Recreation Area • Hells Canyon National Recreation Area, 392,308 acres of total recreation area of 522,838 acres

Wilderness Areas • Eagle Cap, 359,546 acres • Hell's Canyon, 126,903 acres of total 210,703 acres • Monument Rock, 7,080 acres of total 19,780 acres • North Fork John Day, 14,099 acres of total 120,825 acres

Experimental Forest and Range • Starkey, 28,169 acres

Ranger Districts • Baker • Wallowa Valley • Eagle Cap • LaGrande • Pine • Unity

Location • Northeast Oregon and western Idaho

Geography • The largest national forest in the Pacific Northwest, with more than two million acres of forest and rangeland, it contains more peaks over eight thousand feet than the rest of Oregon. Lake Legore, at an elevation of 8,880 feet, is Oregon's highest lake. Elevations range from 800 feet at the Snake River to Sacajawea's 9,833 feet.

Flora and Fauna • Animals: Mountain goats, cougar, bear, elk, deer, bighorn sheep, porcupines • Birds: Magpies, gray owls, goshawks • Fish: Giant sturgeons • Trees and plants: Ponderosa pine, whitebark pine, spruce, limber pine, lodgepole pine, Douglas-fir, subalpine fir, aspen, cottonwood; cactus, bluebells

Recreation • Hiking • Fishing • Boating • Water skiing • Whitewater rafting • Jetboating • Downhill and cross-country skiing • Snowmobiling • Wildlife viewing • Car trips

Points of Interest • Wallowa Mountains • Wallowa Lake • Sumpter Valley Railroad • Hells Canyon

Supervisor
Wallowa-Whitman National Forest
1550 Dewey Avenue
P.O. Box 907
Baker, Oregon 97814
503/523-6391

WINEMA

Area · 1,038,911 acres

Wilderness Areas · Mountain Lakes, 23,071 acres · Mount Thielsen, 25,600 acres of a total 55,100 acres · Sky Lakes, 43,300 acres of a total 113,413 acres

Ranger Districts · Chemult · Chiloquin · Klamath

Location · South-central Oregon

History · Winema, meaning "Woman of a Brave Heart," served as a government-appointed interpreter between U.S. troops and the Modocs. Her efforts are credited with saving many lives during numerous disputes. Winema spent her early life around the Klamath Lakes. Half of the present million-acre Winema National Forest consists of former tribal lands of the Klamath Tribe, who refer to themselves as the *Ouxkanee,* or "People of the Marsh."

Flora and Fauna · Animals: Coyotes, deer, beaver, bear, muskrats · Birds: Sandhill crane, bald eagles, ducks, geese, owls, teals, terns, pelicans, Canada geese · Trees: Whitebark pine, mountain hemlock, lodgepole pine, white fir, ponderosa pine · Wildflowers: daisies, lupine, Indian paintbrush

Recreation · Camping · Hunting · Fishing · Hiking · Water skiing · Cross-country skiing · Snowmobiling · Horseback riding · Packing · Sightseeing · Bird watching · Ice fishing · Sailboarding · Sailing · Picnicking · Canoeing

Points of Interest · Pacific Crest National Scenic Trail along Sky Lakes Wilderness · Pelican Butte Lookout, with view of Klamath Lake · The remote Mountain Lakes Wilderness, Klamath Forest National Wildlife Refuge

Note · Lake-of-the-Woods and Rocky Point resorts both have cabins for rent and other facilities · Visitor centers are near Lake-of-the-Woods and Klamath Basin Wildlife Areas.

Supervisor
Winema National Forest
2519 Dahlia Street
Klamath Falls, Oregon 97601
503/883-6714

McKee Campground adds a community kitchen. 1941.

Beaver were trapped and removed from areas of conflict by rangers in 1936.

Happy youngster enjoys his first ski outing.

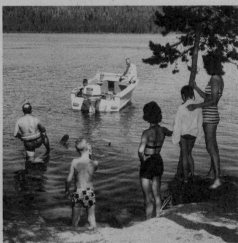

Campers at the Miller Lake Campground tried their luck at water skiing in 1961.

FREMONT

Area · 1,200,537 acres

Wilderness Area · Gearheart Mountain, 22,823 acres

Ranger Districts · Bly · Lakeview · Paisley · Silver Lake

Location · South-central Oregon on the east side of the Cascade Mountains

Geography · Elevations range from thirty-five hundred to eighty-five hundred feet. The climate is mostly dry, as rainfall averages only ten to thirty inches per year.

History · The Paiute, Modoc, Klamath, and Pit River Indians here for eight to ten thousand years, leaving many artifacts.

Flora and Fauna · Animals: Domestic sheep and cattle; 260 species of wildlife including mule deer, jackrabbits · Fish: Crappie, bass, and yellow perch; rainbow, brown, and brook trout · Birds: Red-tailed hawks, goshawks, kestrels, Canada geese, western grebes, coots, yellow-headed blackbirds, prairie falcons · Trees: Ponderosa pine, aspen, sugar pine, whitebark pine, lodgepole pine

Recreation · Hiking · Bird watching · Camping · Hunting · Fishing · Downhill and cross-country skiing · Snowmobiling

Points of Interest · Volcanic geology and resulting earth movement in Slide Mountain Geologic Area · Gearhart Mountain Wilderness · Largest, most definitely-exposed geologic fault in North America from Abert Rim Viewpoint · Big Hole, a huge explosion crater · North Warner Viewpoint overlooking Crooked Creek Canyon · Mitchell Monument · Drake Peak Lookout · Winter Ridge Viewpoint and Summer Lake

Supervisor
Fremont National Forest
524 North G Street
P.O. Box 551
Lakeview, Oregon 97630
503/947-2151

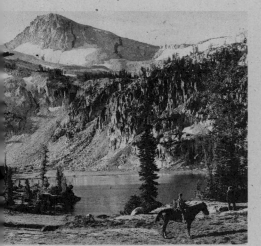

Campers enjoyed the view of Eagle Cap Mountain at Mirror Lake in 1945.

ROGUE RIVER

Area · 629,169 acres

Wilderness Areas · Red Buttes, 16,810 acres of total 20,223 acres · Rogue-Umpqua Divide, 5,877 acres of total 34,904 acres · Sky Lakes, 70,113 acres of total 113,413 acres

Ranger Districts · Applegate · Ashland · Prospect · Butte Falls

Location · Rogue Valley, southwestern Oregon

Geography · Narrow canyons, high, steep ridges, mountain valleys, forested hills. (A portion extends into California.) Elevations range from sixteen hundred feet to Mount McLoughlin's 9,495-foot summit.

History · First called Crater National Forest, Rogue River National Forest was established by President Theodore Roosevelt in 1908. The current name is from Takelma Indians, called *les Coquins,* "the Rogues," by French-Canadian trappers. Gold seekers in the 1850s established the town of Jacksonville. The Pacific Crest National Scenic Trail crosses over Southern Pacific Railroad's Tunnel 13, the scene of America's last great train robbery.

Flora and Fauna · Wildlife: Roosevelt elk, deer, black bear · Birds: Goshawk, wren · Fish: Trout, salmon, steelhead · Trees: Douglas-fir, sugar pine, ponderosa pine, lodgepole pine, white fir, Shasta red fir, noble fir, mountain hemlock, subalpine fir, Englemann spruce, western white pine, Jeffrey pine, incense cedar, Alaska yellow cedar, weeping spruce · Wildflowers: columbine, penstemon

Recreation · Camping · Hiking · Rafting · Horseback riding · Skiing (cross-country and downhill) · Hunting · Fishing · Geological studies · Sightseeing · Backpacking · Snowmobiling

Points of Interest · Narrows of the Rogue River Gorge · Natural Bridge · Union Creeks Historic District · McKee Bridge · Gin Lin Interpretive Trail · Dutchman Peak Lookout, Mount Ashland · Historic Klamath Indian berry-gathering area at Huckleberry Mountain · J. Herbert Stone Nursery

Supervisor
Rogue River National Forest
Federal Building
333 West 8th Street
P.O. Box 520
Medford, Oregon 97501
503/776-3600

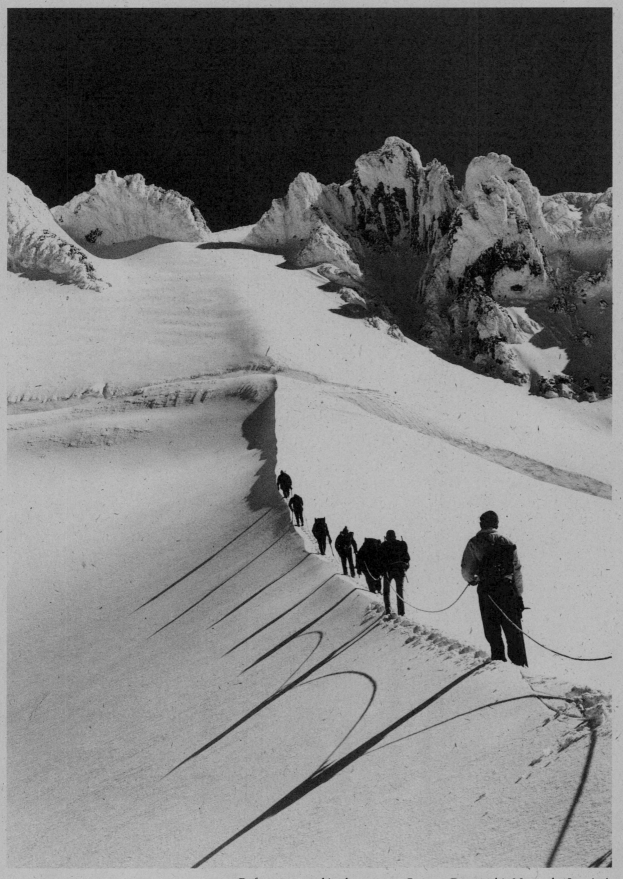

The Mazamas, a Portland, Oregon, mountain climbing club made their way up the hogsback towards the 11,245-foot summit of Mount Hood. 1963.

■ References used in the text are *Oregon Geographic Names* by Lewis A. McArthur and *Exploring Oregon's Wild Areas* by William L. Sullivan.
■ Both the historical photography and all information in the last section, beginning on page 73, are courtesy of the USDA Forest Service.